Etching Techniques

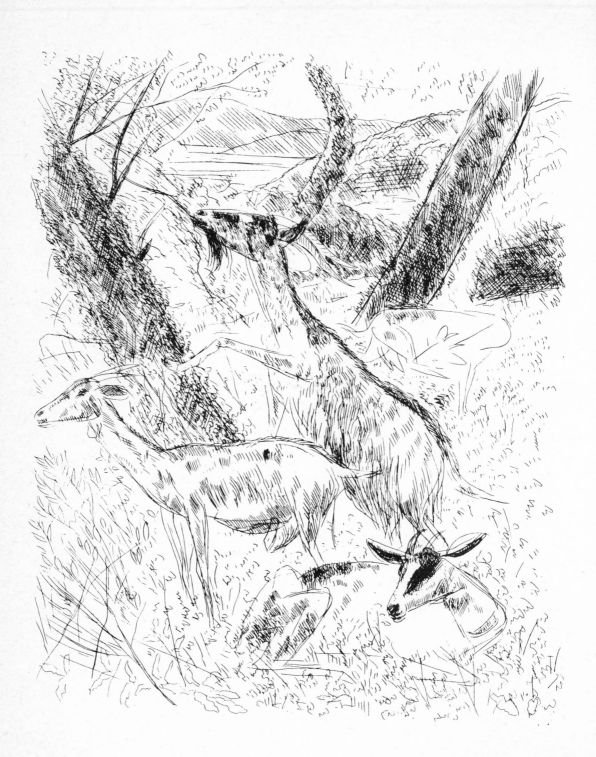

ETCHING
Techniques

PETER COKER

Opposite
Lés Géorgiqués by
Segonzac. Copyright by
SPADEM Paris 1975

B T Batsford Limited
London

© Peter Coker 1976

First published 1976
ISBN 0 7134 3063 X

Filmset by Servis Filmsetting Ltd, Manchester

Printed in Great Britain by
The Anchor Press, Tiptree, Essex
for the publishers
B. T. Batsford Limited
4 Fitzhardinge Street
London W1H 0AH

Contents

Acknowledgment

I should like to thank Nicholas Coker for his assistance in the preparation of this book, without which the book would never have been written.

Also I should like to thank Marion Benham who kindly typed the first draft of the manuscript.

Mistley 1976 PC

The author and publishers thank the following for their kind permission to reproduce illustrations in this book:
 The Arts Council of Great Britain for that on page 28
 The British Museum for those on pages 59 and 66
 SPADEM, Paris 1975 for frontispiece.

Definition

Etching, from the German word *ätzen*, meaning to eat or corrode, is a process by which a design is eaten into metal by acid, for the purpose of printing from it.

The Process

The design is drawn with a needle through a layer of acid-resistant wax laid on a thin metal plate. The layer of acid resistant wax is called *a ground*. A solution of diluted acid is then allowed to eat or bite away areas unprotected by the ground. The ground is removed, ink rubbed into the lines, and a print taken by passing the plate covered with a sheet of paper through a roller press.

Preparing the plate

The Plate

Copper and zinc are the two metals most suitable and most commonly used for etching.

Zinc and copper compared

Each metal has its own characteristics: copper is a hard metal and lends itself to all etching processes; zinc is softer, and when used in drypoint (page 68) or aquatint (page 72), may yield very few good prints. The line etched in zinc will be thicker and more textured than the same line etched in copper. Zinc has the great advantage of being considerably cheaper than copper. Both metals can be purchased ready polished, cut to size and in the most suitable thicknesses of 16 to 18 gauge. Because zinc is so much cheaper than copper, it is the better metal with which to experiment, particularly when only 10 or 15 prints are required.

Cutting a plate to size

If a plate needs to be cut to a smaller size, then lay it face up on a bench and, using a metal straight-edge held firmly or clamped in position, score the plate with a sharp metal point such as a steel drypoint needle or burin, until the plate snaps. Protect the surface of the plate from scratching with blotting paper.

Filing the edges of the plate

To protect the fingers while working, all the edges should be bevelled (page 65). Begin by filing at an angle of less than 45° and gradually increase that angle until only a rough edge on the underside remains. Turn the plate over, remembering to protect

the face, and file the roughness to a rounded edge. The corners can be bevelled with downward pulls of the file. Brush off the filings with a soft brush so that they do not scratch the plate. The filing will have to be repeated after a plate has been submerged in the acid and before any print is taken to ensure that the paper does not tear. The materials, processes and precautions included in the following pages apart from the actual ground and plate themselves, are not, strictly speaking, essential. The precautions against dust and finger marks, often over-emphasized by writers on etching, are there to lessen the likelihood of unsatisfactory results. They are not absolutely necessary, but reasonable care should be taken to ensure confidence in the result. Similarly, with regard to the materials, anything that will effectively obtain the required result, without otherwise damaging the plate or ground, can be used.

Cleaning the Plate

Materials: ammonia, caustic soda, whiting, blotting paper, clean rag.

When cleaning the plate, the alternative agents are whiting and water alone, whiting and a weak solution of caustic soda, or whiting and a solution of ammonia. If ammonia is to be used, add

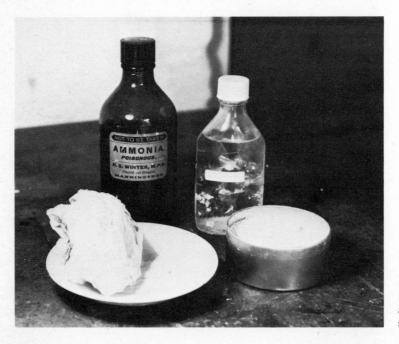

Materials: ammonia, ammonia solution, clean rag, saucer of paste, whiting

10

a small amount to the same amount of water and form a paste by mixing the solution with whiting in a saucer. Rub the paste over the whole surface of the plate with a piece of rag. Rinse the paste off thoroughly with running water, and if there are no traces of grease remaining on the surface the water should flow evenly over it.

No whiting should be left on the rough edges or on the back of the plate, or it may find its way on to the surface and interfere with the resistance of the ground. Drying the plate can be done by gently warming it or by using blotting paper. Handling the plate should now be done with care, for fingers will transmit grease. As copper is a naturally greasy metal this process is quite important, for grease on the plate is one of the primary causes of foul biting. Foul biting occurs when the ground does not adhere properly to the plate, allowing the acid to penetrate it.

Cleaning the plate with a solution of whiting, water and ammonia

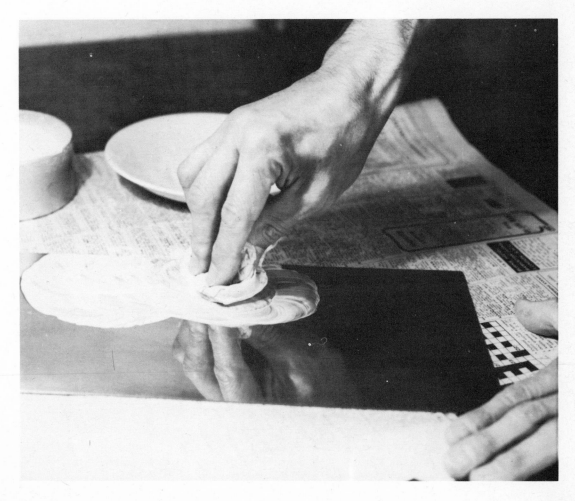

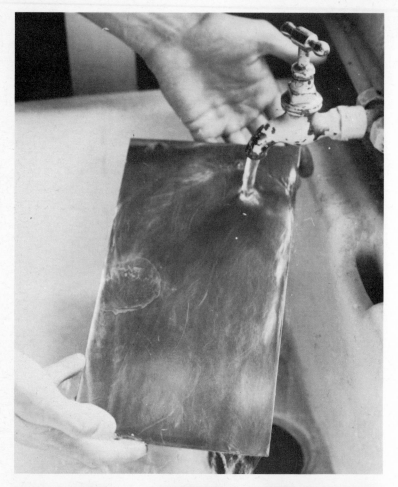

Washing off the paste under running water

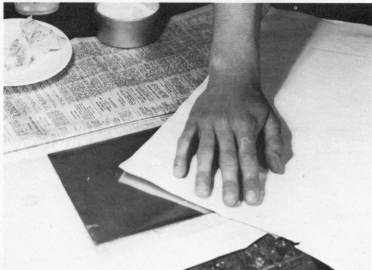

Blotting the plate dry. Note that the fingers are clear of the clean surface

Laying the Wax Ground

Materials: hot plate, gas ring, dabber, roller, hard wax ground, blotting paper.

The principle of any ground is that it should resist acid. There are two types of ground, soft and hard. Soft ground will adhere to anything with which it comes into contact and the impression left in the ground will be bitten into the plate by acid. Its function and application can be found in the chapter, 'Drypoint and other processes' (page 70). It is not used when direct drawing is required on the plate. Hard ground is used for this purpose.

Hard ground must be sufficiently hard to allow handling and to ensure that it does not stick to the needle in drawing. It is best if the ground disintegrates beneath the point of the needle so that it can be blown off in the form of dust. At the same time the ground must be elastic enough to enable the needle to draw finely without chipping.

Grounds can be either bought in etching balls or made; it is just as cheap to buy them and bought ground will often be more satisfactory than home-made.

Materials: etching ball, hard and soft grounds and liquid ground

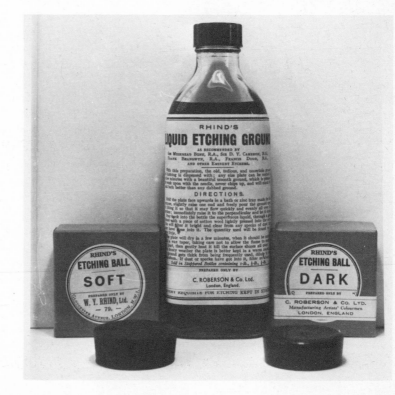

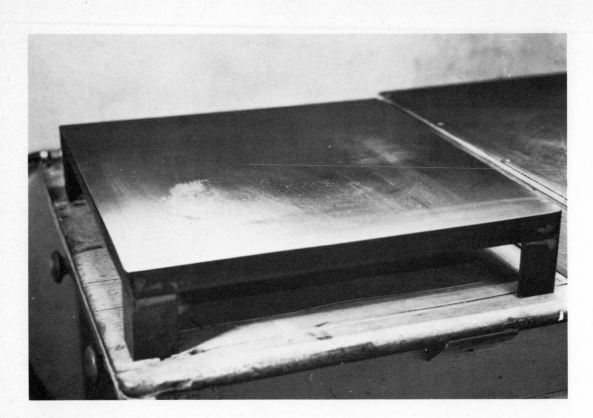

A liquid hard ground can be used. (See illustration on page 19.) Full directions are given on the bottle and the method is comparatively straightforward. However, liquid ground does have a number of disadvantages, the most important being that when the surplus ground is returned to the bottle, impurities tend to get in it. On the other hand, if it is thrown away after each use it is not economical.

The ground is applied by heating the plate, melting a little ground on it, and then spreading a thin layer with a roller or a dabber. There is a tendency to lay too thick a ground with a dabber, though it is essential if the plate is not flat, as a roller will not roll the ground into hollows. A good plastic roller is the easiest tool to use.

To heat the plate use a hot plate, consisting of an iron plate 50 cm × 50 cm (20 in. × 20 in.) standing 10 cm (4 in.) off the table and heated by a moveable gas ring beneath. The hot plate should be larger than the area to be grounded so that it has a variable temperature across its surface. If the ground needs more or less heat the plate can be quickly manoeuvred to make the necessary adjustment. See Appendix for making or buying a hot plate.

Hot plate. Heated by gas ring beneath, and used when laying a ground and printing

Calor gas ring, tap and
cylinder

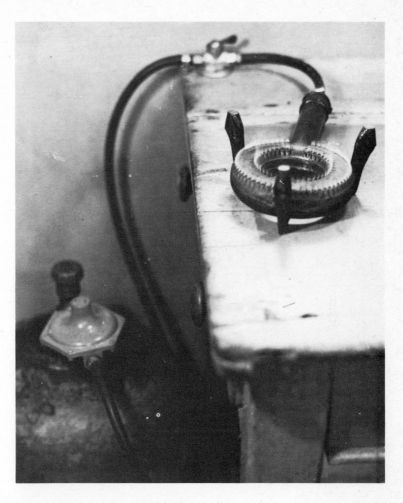

Heating the Plate

Heat the plate until the etching ball melts on contact; the plate
should be an even temperature all over. Melt a small amount of
wax ground on to the plate, using the shiny end of the etching
ball, as any impurities in it will have sunk to the bottom during
its manufacture. If the plate is large it will be necessary to apply
the ground by sections. Care should be taken to prevent particles
of dust from being laid with the ground, as the ground might
then no longer resist the acid.

The dabber
Using a dabber (see Appendix) in a rocking motion from the
wrist, spread the wax over the plate as quickly as possible. The
ground should then be brought to an even consistency with quick,
light dabs; again, the action comes from the wrist. A gentle heat

15

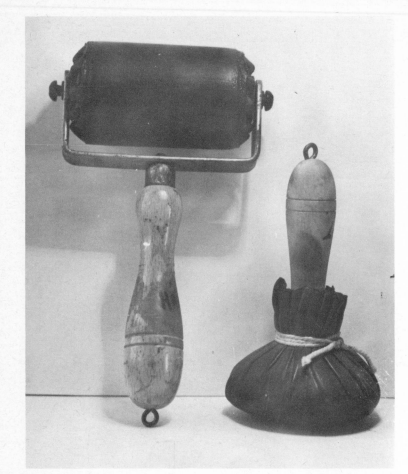

Roller and dabber, both used
in laying grounds

Opposite right
Warm the plate on the hot
plate and apply dabs of
ground roughly 5 cm (2 in.)
apart

may be needed to flatten out the textures left by the dabber, and
the ground should at that point shine brilliantly but not be
allowed to remain too long on the heater for fear of burning.

The roller

If a roller is used, roll the wax over the plate. The roller will at
first pick up the wax and then distribute it about the plate. The
slower and heavier the ground is rolled, the thicker it will be;
the faster and lighter it is rolled, the thinner it will be. If the
ground is laid too thickly it will become brittle and crack off in
the acid. If the ground is laid too thinly it will be penetrated by
the acid. When rolling it is best to roll in more than one direction;
that is, to cover the whole surface by rolling parallel to one side
and then turn it to roll at right angles to that side. The plate
should be manoeuvred by placing the finger tips near the edge on
the underside of the plate.

Opposite right
Spread the ground with the
dabber evenly over the plate
with a dabbing and rocking
action

16

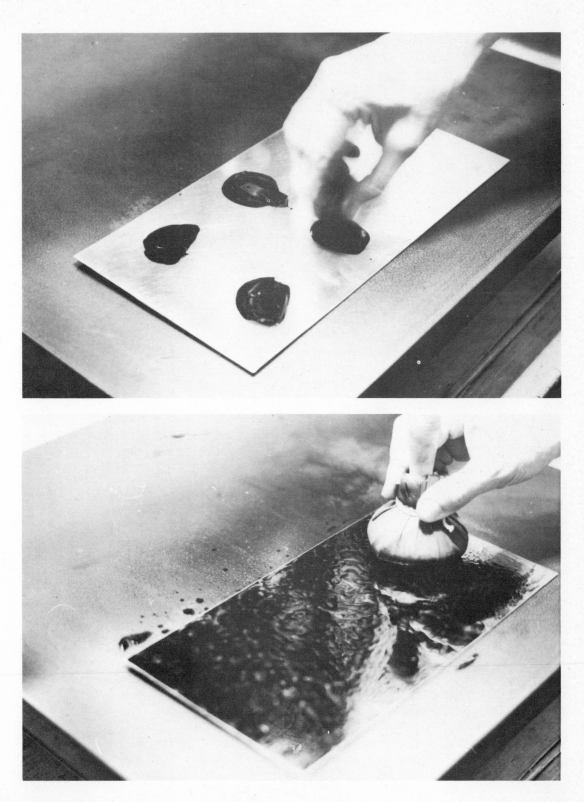

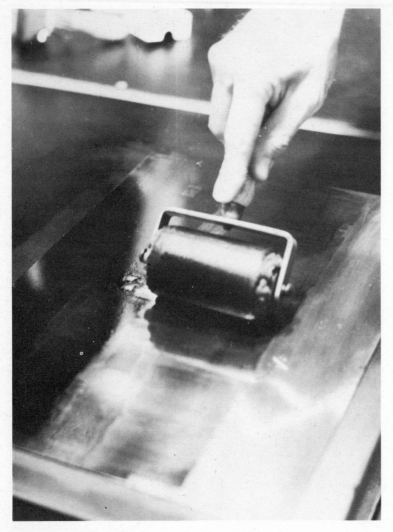

The Correctly Laid Ground

The appearance of a correctly laid ground should be a semi-transparent brown; an even and thinnish covering of the plate. During its application, the ground must not bubble, for then it is too hot and will not adhere properly to the plate. It must also not be too tacky, for in that case it would not be hot enough, and lift off with the roller. This would necessitate reheating to enable the roller to take up the ground again and re-apply it. As long as the ground does not scorch, this process can be repeated as often as required. The ground must not smoke, for then it is burnt, permeable to acid and will therefore need to be removed and a new ground laid.

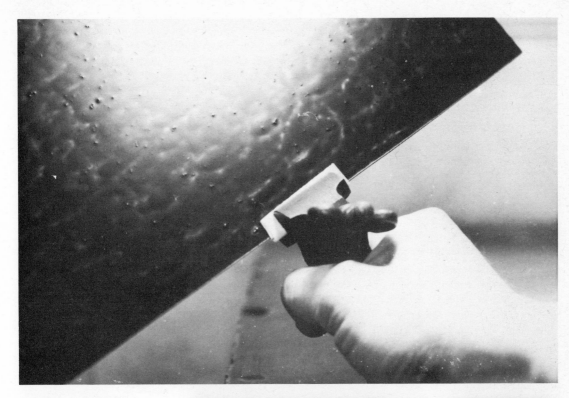

A poorly laid ground, showing bubbles and blotches. Such a ground will be penetrated by the acid

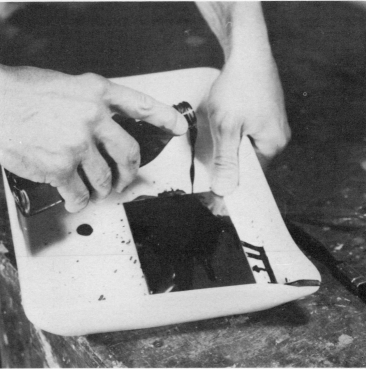

Applying a liquid ground. Hold the plate steady and gently pour the ground on to the plate. Note the lip in the tray for returning the surplus ground to the bottle

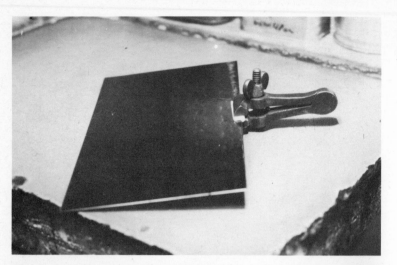

Grip the plate with the hand vice, protecting the plate from the jaws of the vice with blotting paper

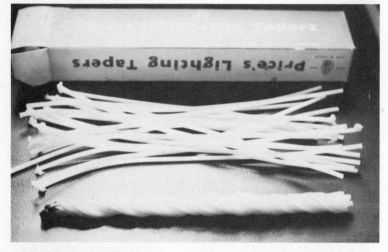

Tapers. 8 or 10 tapers twisted together to provide a concentrated flame. Warm the tapers in hot water so that they soften, do not break, and stick together

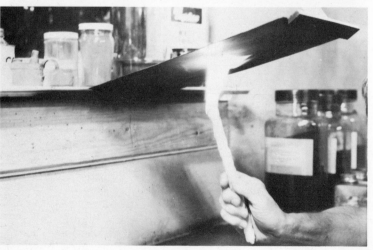

Smoking a large plate by means of clamps attached to the wall

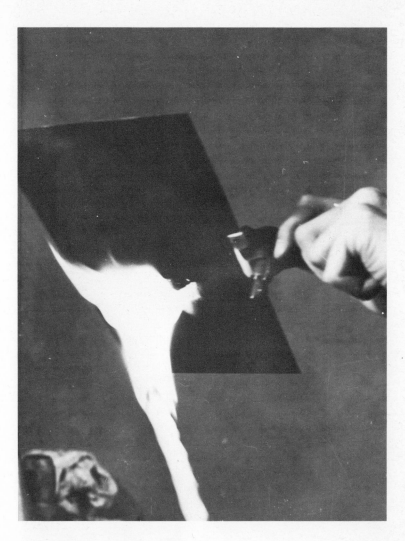

Smoking the Plate

Materials: hand vice, blotting paper, wax tapers.

The reasons for smoking a plate are that the carbon from the tapers darkens the ground and heightens the contrast between the metal and the remaining ground when the design is drawn into it. It flattens out the textures left by the roller and strengthens the ground. Smoking is best done while the plate is still warm to enable the carbon to be properly incorporated into the ground. While the plate is on the heater, clamp on the hand vice, gripping the plate at the point which affords maximum support. Protect the plate from the jaws of the vice with blotting paper. Holding the plate with the grounded surface downwards, smoke the

21

ground with the wax tapers. The flame should lick the plate yet be constantly moved across it to prevent any scorching of the ground, which will easily happen if the tapers are held in one place. Similarly, the wick should not be allowed to touch the ground. The ground during this process should shine brilliantly, but if it is scorched will blister and turn matt. The correctly smoked plate will, however, turn matt on cooling. Care should also be taken to prevent wax dripping from the tapers onto the heater, for if the rollers pick it up all succeeding grounds will be damaged. If the surface is dull after smoking, the plate should be re-heated so that the wax may absorb the soot. If the carbon has not been absorbed sufficiently it will rub off when the ground is cool.

Large plates offer a slight problem, but one which is easily solved. One edge of the plate is supported by a narrow strip of wood secured to a wall. The opposite edge is supported by a piece of wood, hinged to the wall. See photograph.

The plate is best left to cool leaning at an angle against a wall or box, face inwards to prevent dust from settling.

Varnishing the Back and Edges

The back and edges of a plate should be varnished to protect them from the acid. It is best done while the plate is still warm, to accelerate the drying. Apply the varnish with a brush, being sure to cover the whole surface. Take care not to touch the grounded face or allow the varnish on to it.

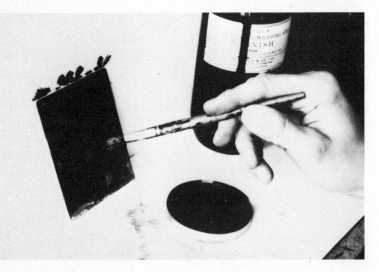

Varnishing the back of the plate and its edges with stop-out varnish

Drawing on the plate

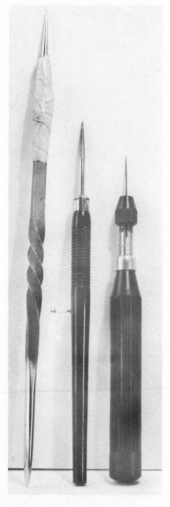

Materials: etching needles, tracing paper, carbon paper, stop out varnish.

Drawing on to a plate is not the same as drawing with a pencil on paper; the action of the acid should be considered. Acid will attack the plate where the ground is removed.

Etching Needles

An etching needle can be made by pushing an ordinary needle into a cork, though home-made needles tend to be too light compared with the heavier manufactured ones. The needle should not be too sharp, otherwise, in the process of cutting the wax it will scratch the metal. Hold the needle like a pencil, and draw into the ground, taking care not to use too much pressure, otherwise the line will be shaky and uneven.

Transferring a Design on to the Plate

Preliminary drawings on paper can aid the placing of a design on the plate. If the drawing is to be transferred on to the plate, one of the following methods will be found useful.

Make a tracing on tracing paper, dampen it, and run it face down on the grounded plate through the press. The faint grey imprint on the ground can then be gone over with a point. Using this method the print will be the same way round as the original drawing, which is important if lettering is involved. However, the remainder of the work will have to be done in

23

reverse, and any details missing on the plate must be filled in with the aid of a mirror.

If the drawing on the ground is to be the same way round as the original (thus printing in reverse), interleave the plate and the drawing with carbon paper and go over the lines with a hard blunt point.

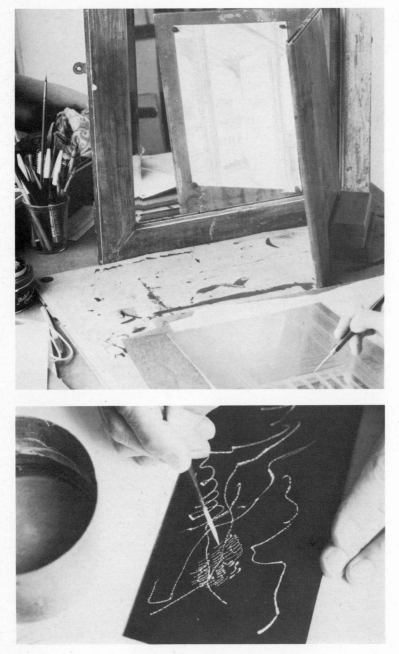

Adding details to a plate, with the aid of a mirror

Drawing on the ground with white poster colour

If a drawing is to be transferred to a plate of a different size the drawing and the plate must be proportional to one another.

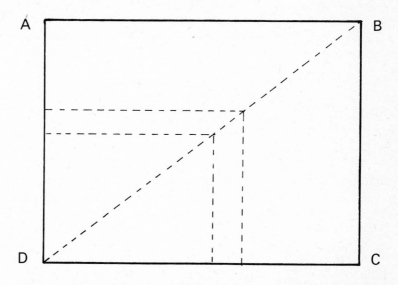

All rectangles with two adjacent sides lying along DA, DC and with a diagonal along DB are proportional to each other and to ABCD.

Square up the drawing by the method illustrated below.

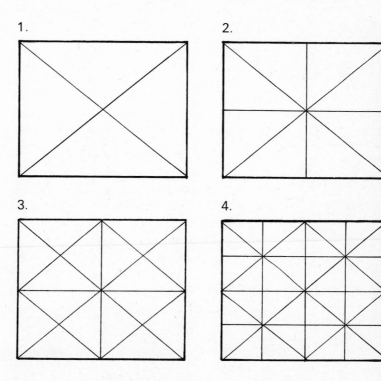

Square up a piece of tracing paper of the same size as the plate so that it corresponds to the squaring up of the drawing. Transfer the design from the drawing to the corresponding rectangles on the tracing paper.

The design can now be transferred on to the plate by one of the methods described above.

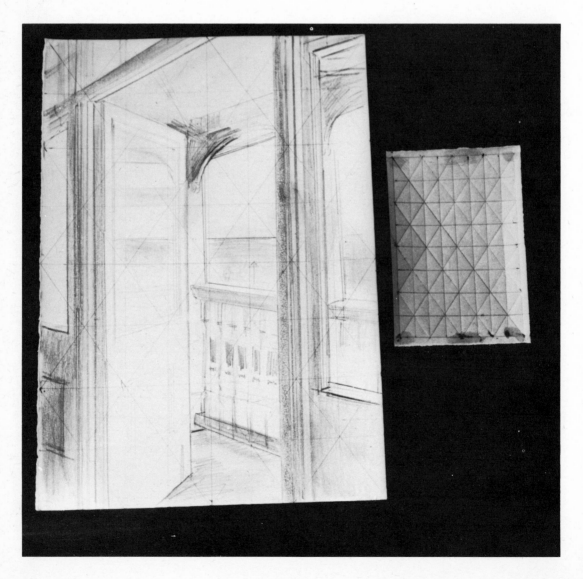

Stopping Out Mistakes

Any mistakes can be painted over with 'stop out' varnish, a quick-drying varnish that resists the acid. Take care when drawing over 'stopped out' areas as the varnish may splinter. Also, two or three coats of varnish should be applied to bitten lines because the early coats sink into the lines and do not protect the edges. A brush dipped in turpentine and mixed with hard ground to form a paste can be used in the same way as stop out varnish.

Methods of Producing Light and Dark Tones

Though many needles can be used for different thicknesses of line, skilful controlling of the plate in the acid will produce the same effect. For example, dark passages can be produced by many lines closely grouped or cross-hatched, light passages by fewer lines, bitten to the same depth. The same variation can be achieved by biting the plate only sufficiently for the light tones which are then stopped out to prevent them from being bitten further and becoming dark, and returning the plate to the acid for the dark tones.

Two basic methods of drawing on the plate can be used. Draw the design as complete as possible into the ground, and leave the plate in the acid until those parts to be lightest are bitten sufficiently. Remove the plate, stop out the light areas, and return to the acid until the next darkest tones are bitten. Continue this process until the darkest tone is etched on to the plate. The other method is to draw only the darkest passages and bite them. Remove the plate from the acid and draw in the passages that are to be the next darkest, and so on until the drawing is complete.

It is most likely that a combination of these methods will be involved in finishing the plate. What is common to both is a judgement of the time required to bite to a certain depth. In general, the longer the plate is left in the acid, the deeper it will bite and the darker it will print. If one minute is taken over the first bite, two minutes will be needed to double the strength of that line, four minutes to double that, and so on in a geometric progression.

The important point is that drawing and biting are inextricably linked and should be thought of as parts of the same process.

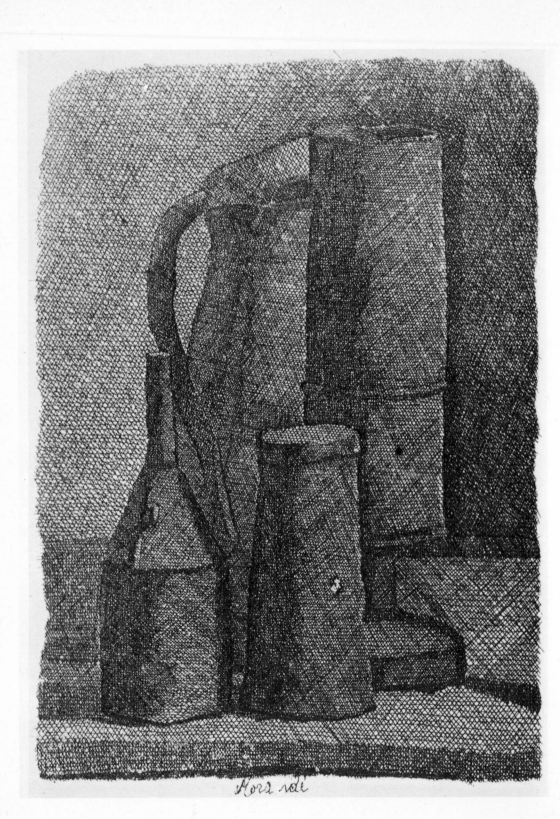

Etching the plate

Materials: acids, acid trays, measure, funnel, water, ammonia, bottles.

Care should be taken when dealing with the acid, long hair should be tied up, and cuffs and ties secured. Always add acid to water. Each acid attacks a metal in an individual way.

Acids

Nitric acid on copper
The action of nitric acid on copper produces gas which is given off in bubbles. The bubbles show evidence of biting and should be gently brushed from the plate with a feather. If the bubbles are allowed to remain on the plate they will prevent the acid from biting regularly, producing a shallow and rough-edged line. The boiling action of the acid removes some ground either side of the line so that a strongly bitten line will be broad as well as deep.

When nitric acid is used some lines will begin to bite sooner than others. The variation is subject to the amount of metal exposed; the more metal, the quicker the action. Also, acid warms as it bites and the warmer an acid is, the quicker it bites. A rise in temperature of 10% will almost double the speed of biting. It is essential then, that the action of the acid is watched carefully.

For an acid solution of average strength add 1 part nitric acid to 3 parts water. For a stronger solution, add 1 part nitric acid to 2 parts water. If the mixture is of the correct strength, a

Still Life with Four Objects by Morandi. Etching. The tones were produced by multiple cross-hatching

29

copper penny will jump due to the bubbles escaping from the underside. Before using the solution add a piece of copper or some copper filings, enough to turn it light blue. This removes the viciousness of the acid.

The solution can be used many times before becoming exhausted, when lines are relatively underbitten and the colour becomes a dark blue. Empty the exhausted acid away, keeping about half a cupful to add to the new solution, to remove its viciousness.

Nitric acid on zinc
As zinc is softer than copper, the solution should be weaker. Nitric acid will bite zinc evenly regardless of the density of lines. A slowish bite will be effected by 1 part nitric acid with 10 parts water. Do not, however, test with copper.

Dutch mordant
Dutch mordant is a solution of hydrochloric acid, potassium chlorate and water. It is usually only used for copper and does not produce gas. It is an acid that attacks slowly and evenly all the exposed areas and is especially useful in biting widely spaced and fine lines that may be ignored by nitric acid. It is a good acid for biting cross-hatched lines because, unlike nitric acid, it does not damage the edges. As this acid does not produce bubbles its action is unseen, and particular care should be taken to observe its effects on the lines, which will become dark as they are bitten.

It is a good idea to bite a plate that has both single lines and whole areas of cross hatching in Dutch mordant for a short time to open all the lines, and then transfer to nitric acid. Complicated lines should as a rule be begun with a slow mordant. Dutch mordant produces a comparatively smooth and narrow line where the trench is deeper in proportion to its width, because unlike nitric acid it does not have a boiling action to break up the ground.

A very slow solution, especially in cold weather, is produced by mixing 10 parts hydrochloric acid, 2 parts potassium chlorate and 88 parts water. A quicker mordant: 20 parts hydrochloric acid, 4 parts potassium chlorate and 76 parts water. The latter solution will bite delicate lines in about a quarter of an hour, medium lines in half an hour and strong lines in 1 to 2 hours.

To mix the solution, dissolve the potassium chlorate in hot water in a saucepan. Add the hydrochloric acid to the rest of the

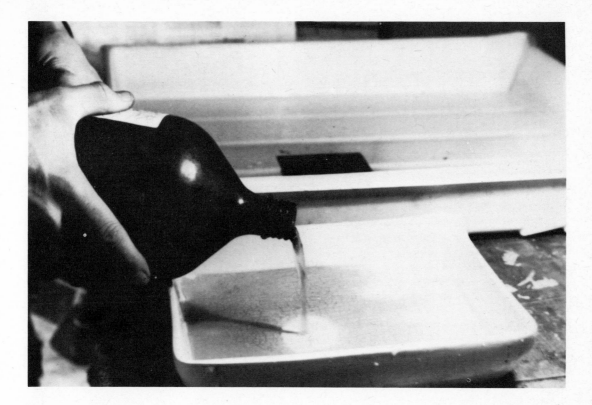

Pouring out the acid, gripping the bottle firmly to prevent splashes

water. Pour the potassium chlorate solution into the hydrochloric acid and stir well. Fumes will be given off during the first 5 minutes of mixing, but will quickly disperse. Take care not to inhale them.

Acid bottles

Acids and solutions should be kept in solid *glass* bottles with good stoppers. They should be clearly marked and a solution made up for one metal should never come into contact with that for another. If there is any doubt as to whether a bottle contains nitric or hydrochloric acid, dip a piece of copper in a sample and if the copper turns brown the solution is hydrochloric acid, if bubbles are given off, the solution is nitric acid. The sample should then be reserved for copper baths or thrown away.

Acid trays

The tray most economical to use as an etching bath is a heavy quality plastic photographic tray. These are light and available in many different sizes. A bath can, however, be improvised by building walls with bees wax or *Plasticene* on to a heavy glass plate or even on to the etching plate itself. Though the walls are

liable to leak, the latter is a useful method when biting small defined areas individually.

To calculate the proportions of acid to water
Calculate the amount of water required by filling the tray so that the plate is covered. Remove the plate and funnel the water into a large jar. To the water add the required proportion of acid. Always remember, *add acid to water*. If water is added to acid, the heat generated might crack the bottle. Some heat is generated in mixing solutions of acid, and a bottle should not be stoppered until the mixture is quite cool.

At this stage it is advisable to check that the edges and back of the plate are properly varnished.

Acetic acid
Before the plate is put into the acid, immersion in *acetic acid* for about five minutes will remove any traces of grease in the lines. Alternatively the plate can be left to soak in vinegar for 25 minutes.

Placing the plates in acid baths and removing them
Try to avoid splashing when placing a plate in a bath; put one end of the plate in the bath and gently lower the other. When the plate is taken out of the acid bath, rinse under running water and blot dry. Before stopping out, the plate must be dry, for a wet surface will not hold varnish.

It is important to remember that a broad line must be bitten deep in order to print black. The depth of the bite can be checked by testing the lines with a needle. If there is still some doubt, remove the plate from the acid, rinse and dry it and look along a line in the direction of the light. A small section of ground can be removed from the edges of a line with white spirit and a rag, the line inspected, the section stopped out and redrawn, and the plate returned to the acid. Withdraw the plate immediately if the ground shows signs of breaking up.

Gradated biting
Gradated biting can be effected by placing the end of the plate to be most bitten in the bath and holding the other end clear of the acid, rocking the plate to prevent the formation of defnite bands. It is possible to achieve the same effect by covering the plate with a sheet of blotting paper and dropping acid on to those areas that are required dark; the further the acid diffuses through

The bubbles forming on a copper plate in a solution of nitric acid. The bubbles appear on those areas exposed to the acid

the blotting paper the shorter time it will have to bite, and the lighter tone it will etch.

Spit bite
Very small areas can be individually bitten by encircling them with a barrier of saliva and then applying the acid. The acid can be controlled by using blotting paper.

Solvents for Varnishes and Grounds

When biting is complete, remove all varishes and grounds with white spirit or methylated spirit. Grounds are soluble in paraffin or white spirit while shellac and rosein varnishes are soluble in methylated spirit. Thus, incidentally, it is possible to dab varnish off a ground with a rag soaked in white spirit. The plate will have to be cleaned with whiting before a new ground is laid.

A large glass or plastic funnel is essential for returning the solutions to their respective bottles.

Precautions

Good ventilation is necessary in the room, for nitric acid baths give off toxic fumes. A strong nitric bath with copper will produce poisonous fumes. It is advisable not to lean over the bath for long periods of time. If fumes are inhaled and nausea or

nose bleeding result, then take a little bicarbonate of soda.

Though it is quite safe to put hands into the dilute solutions, they should be washed thoroughly under running water immediately afterwards. Ammonia will help to counteract acid burns on skin and clothing.

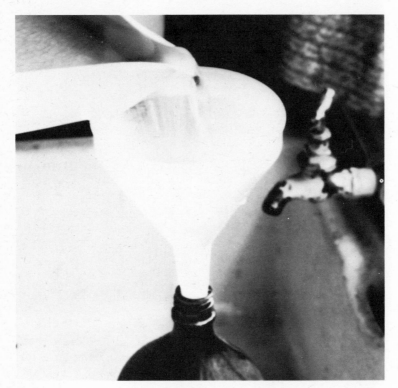

Pouring the acid back into the bottle

Heavy glass bottles for strong acid

Printing

The plate is inked and wiped with a muslin pad which forces the ink into the bitten lines. The excess ink is removed with further pads and the plate polished by hand wiping. Together with a dampened sheet of paper, the plate is passed once through the press. The pressure forces the paper into the lines which appear in relief. The print is gently lifted, stacked and dried. The plate is inked up as before and another print taken.

Papers

Hand-made papers and good quality machine-made papers, such as the excellent 'mould-made' papers by Barcham Green, are available from etching suppliers. A cheaper good quality paper such as *Bockingford* should be used for proofing while the expensive papers are reserved for editions. Cheap reject paper known as *Retree* or *Outsides* has minor blemishes but is well worth using. It is more economic to buy paper in quires (25 sheets) than in single sheets. When ordering a paper, the maker's name, thickness and size, colour, 'laid' or 'wove', and kind of surface should be specified.

'Laid' and 'wove' refer to the method used in making the paper. When the paper is held to the light, laid paper reveals parallel lines, caused by the wires of the mould on which it was made. Wove paper has no such lines, being made, as its name implies, on a closely woven mould.

Paper can be purchased sized or unsized. Unsized paper is called 'waterleaf' and is absorbent like blotting paper, while sized paper is much less absorbent and tougher.

The weight of a paper indicates the thickness. It refers to the weight of a ream (500 sheets). The desired weight depends upon the size of the paper. Good relative printing weights are as follows:

Dampening the paper
(a) Tearing paper to correct size, using a steel ruler. Tear paper rather than cut it in order to leave a deckled edge

Name of paper	Dimensions		Weight per ream	
	in.	*mm*	*lb*	*kg*
Double Elephant	$40\frac{1}{2} \times 27\frac{1}{2} =$	1030×700	133	63
Imperial	$30\frac{3}{4} \times 22\frac{1}{2} =$	780×570	72	35
Royal	$25 \times 20 =$	635×505	54	24

'HP' denotes hot pressed, and has a smooth surface. 'NOT' is a paper not hot pressed with a medium surface texture, and 'Rough', as the name implies, has a rough surface.

Paper should be selected for characteristics that will suit a particular plate. The weight, texture, size content and structure all have some bearing on the result.

Dampening the Paper

(b) Dipping the paper in water. Let the sheet drain before sponging

Materials: proofing paper, sink, sponge, blotting paper, glass or plastic sheeting.

This depends entirely on the type of paper; the more size in a paper, the more dampening is necessary. For sized paper, dampening is best done the night before printing. Unsized 'waterleaf' paper need only be dampened a short time before printing, and a thin waterleaf as little as an hour before. Never leave waterleaf paper in water otherwise it will disintegrate.

Calculate the number of sheets needed for the printing session including extra sheets in case of spoilt proofs.

Fill a large tray or other clean container, sink or bath with water. Allow a sheet of paper to soak in this water for half a minute, drain off the surplus water and gently sponge on to a large piece of plate glass or plastic. No pockets of air should remain beneath the paper. Take the next sheet and repeat the process, laying it on the previous sheet. When each sheet has been sponged, the stack is covered with a similar sheet of plate glass, or the plastic is folded over it.

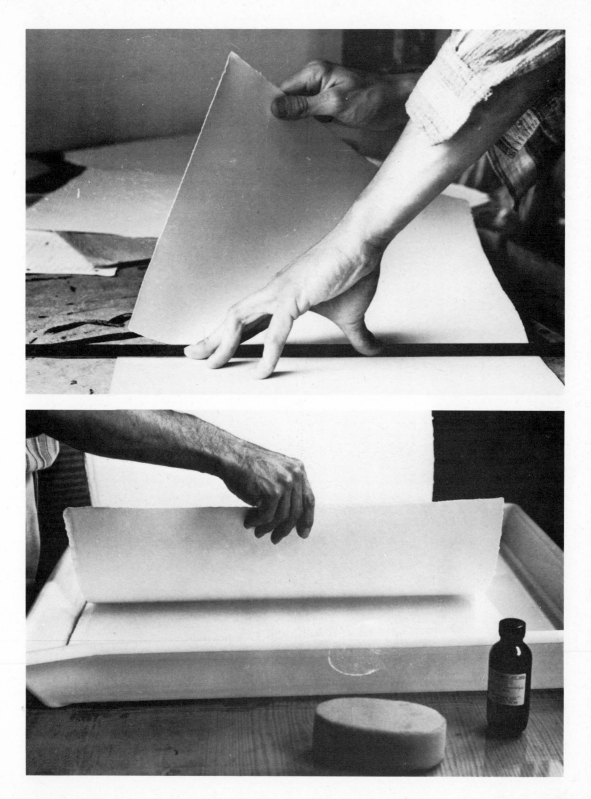

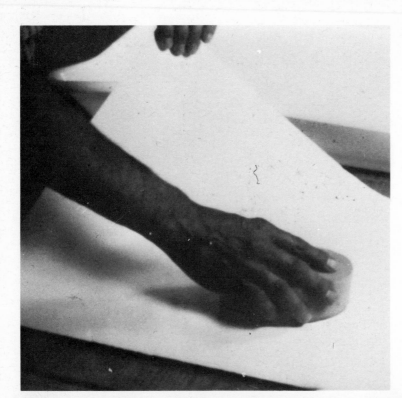

(c) Sponging the surface to remove air bubbles and to ensure even dampness

(d) Stacking the paper. Note that damp paper should be handled at opposite corners

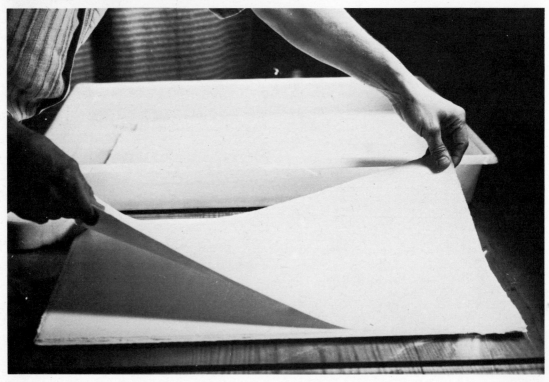

The Ink

Materials: palette knives, grinding slab, muller, light and heavy copperplate oils, Frankfurt and Heavy French Black.

Mixing ink
(a) Materials: jars of ink powders, cans of oil, muller, and palette knives all on an old lithographic stone used as a grinding slab

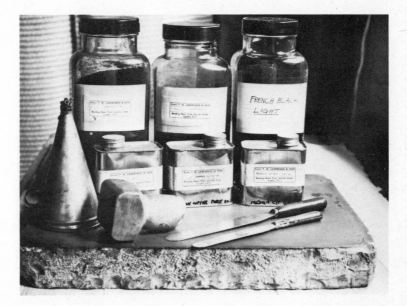

Though printing inks can be bought ready to use, there are a number of advantages in preparing one's own. The ink is much cheaper and the consistency can be varied to suit the various etching processes. Ink mixed as described below will dry to a matt surface with a certain warmth of colour which is not always predictable in manufactured preparations.

Though Frankfurt Black and Heavy French Black can be used separately, a good dense black is obtained by mixing Frankfurt Black with one-third of the same amount of Heavy French Black. Mix the powders on the grinding slab and, using a palette knife rub a little heavy copperplate oil into the powder until the mixture becomes flaky. Because the oil tends to stick to the palette knife and the grinding slab, use a second knife to scrape them clean. Add a little light copperplate oil and mix to form a paste. It is important not to add too much oil as the ink becomes more liquid when ground. Do not mix too much ink at a time as grinding will take much longer.

Grinding
Scrape most of the paste to one side of the slab and grind the remainder with the muller (see Appendix). Using both hands,

put the weight of the whole body into pushing and drawing the muller, stopping at intervals to scrape ink from it. When the ink is consistent, completely smooth and runs from a palette knife in a stop-and-flow motion, scrape it to the side and grind a little more of the paste. Repeat the grinding until the whole is of the right consistency. If the ink is jelly-like or dead on the knife, it is too thick and needs more oil. If the ink flows evenly and quickly it is too thin and needs more powder. In either case the ink will have to be thoroughly reground. The ink can be used at once or kept in a jar of water until needed.

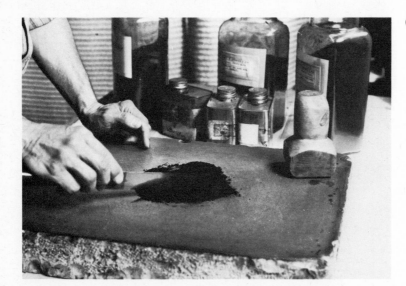

(b) Mixing the ink powders

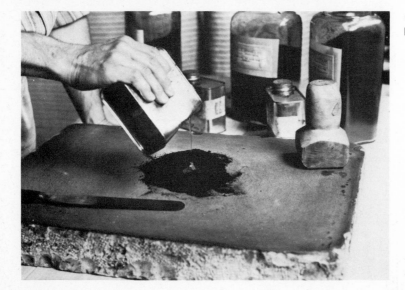

(c) Adding a little oil to the powder

(d) Mixing the oil into the powder throughly with a palette knife

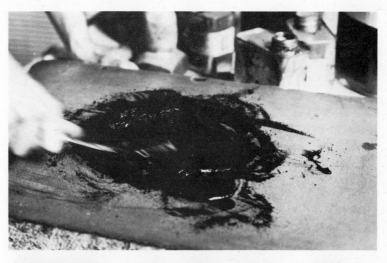

(e) Scraping ink from one palette knife with another, ensuring that unmixed ink is not left on it

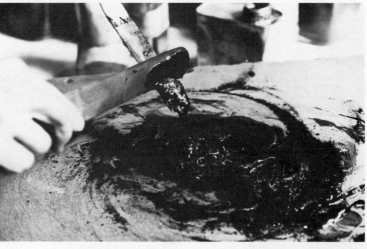

(f) Gripping the muller with both hands and, using the whole weight of the body, grind the ink

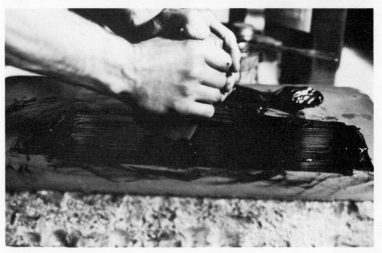

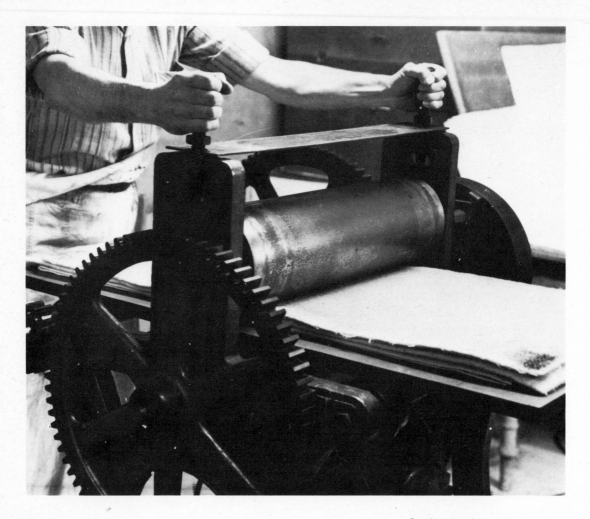

Setting up the press;
tightening the screws,
making sure that the pressure
is equally distributed

The Press

Materials: etching press complete with blankets, tissue paper, blotting paper.

The press is by far the most expensive piece of equipment used by an etcher. A steel bed plate runs between two evenly surfaced rollers supported in a metal frame. The pressure is adjusted by means of a screw at either end of the upper roller. This roller is turned directly by a hand wheel or by an electric motor. Presses at local art schools or printing workshops may be available under supervision for a small fee. Alternatively they may be bought from the suppliers listed.

Setting up the press

To set up the press, release all the pressure from the pressure screws. Lay two *Swanskin* blankets on the bed, smooth surface down as it is this fronting that will back the print, and then two coarser blankets or felts to give resilience. Send the bed through the rollers until they grip the blankets. Tighten the screws by hand, making sure that they are even. Fold the blankets back over the roller. Swanskin blankets are not ordinary blankets and should be purchased at one of the suppliers listed.

The pressure

To check the pressure, lay the clean, uninked plate face up on the bed and cover with a sheet of blotting paper, pull down the blankets and send through the press. Every line of the plate should appear in relief. The edges of the plate should appear equal on the paper, but if one side is more prominent, the pressure is uneven and can be rectified by a slight turn of the appropriate screw. If the finest lines do not appear at all, there is insufficient pressure, but if the surface of the paper tears the pressure is too great.

Marking the bed

The size of the paper will be chosen to give a good margin around the image. In order to maintain a similar margin on each print, mark the bed of the press to the size of the paper and the relative position of the plate. This can be done with crayon or biro.

Inking

Materials: hot plate, jigger, dabber, roller, tampon, muslin, whiting, rag, tissue paper.

With the plate on a hot plate about blood temperature, take up some ink from the grinding slab with a dabber or tampon, and with a gentle dabbing and rocking motion force the ink into the lines. A roller can be used equally well, but whichever method is chosen, care should be taken not to slide and scratch the plate. The plate should show a uniformly black surface with no glint or shine.

Printing: the layout of the bench. From left to right: hot plate, jigger with 3 pads of muslin, grinding slab with ready prepared ink. The press should be only a few steps away

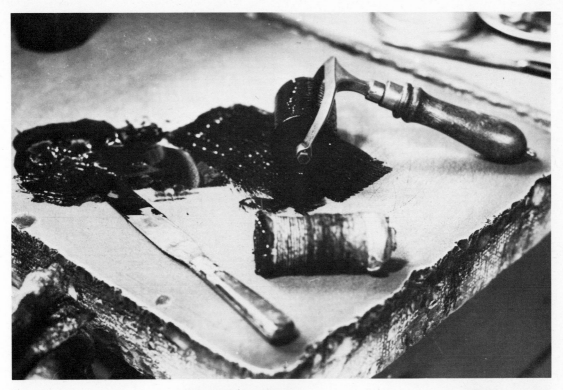

Materials for inking the plate: palette knife, roller, and tampon which can be used effectively to force the ink into the lines. Always check the tampon, before using, for grit that might scratch the plate

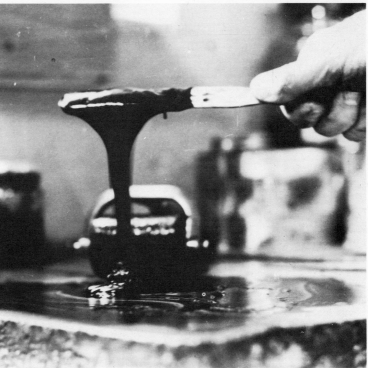

Inking the plate
(a) The correct consistency of the ink. It should flow from the knife in a stop-and-flow motion

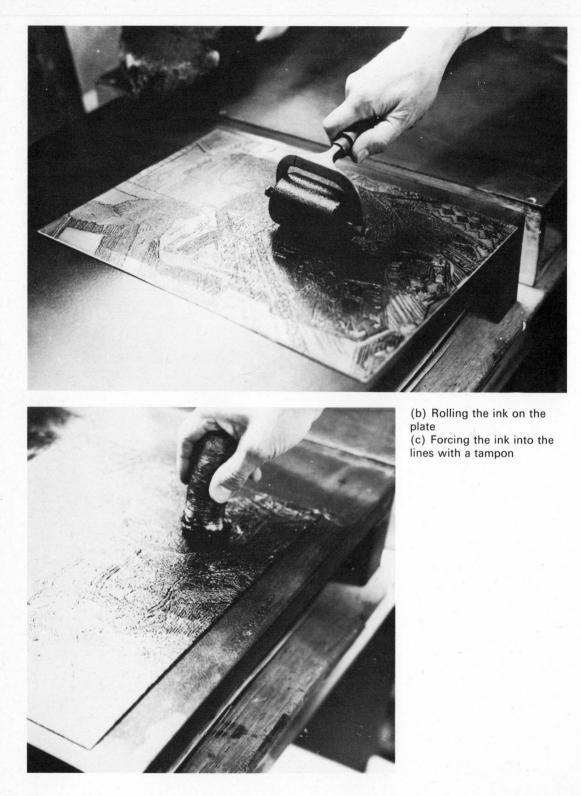

(b) Rolling the ink on the plate
(c) Forcing the ink into the lines with a tampon

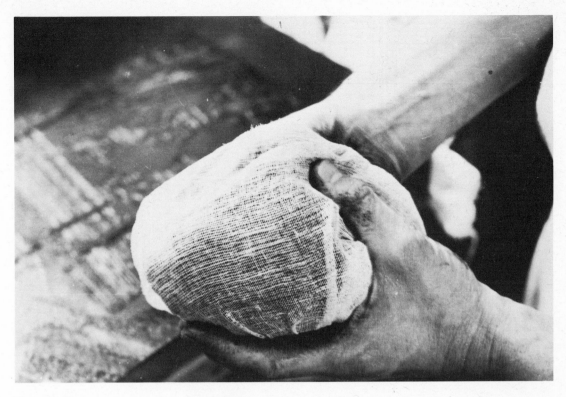

The rag wipe
(a) The first of the 3 muslin pads, lightly impregnated with ink

Rag wipe

The plate is now wiped with a rag. Three pads of muslin are required. The muslin should have its dressing removed by rubbing it together until soft. Do not roll the material into a hard ball, but gradually take up corners and edges into the palm of the hand to form a soft pad. About 45 cm (18 in.) square of material will be needed. A pad should not be used unless it has ink already in its texture. Similarly, if the muslin is hard with dry ink, add a little wet ink and rub the pad on the hot plate until perfectly soft.

First pad

Support the underside of one end of the plate with the left hand and use the first pad with a little pressure to remove the bulk of the ink. When it becomes loaded, turn the pad so that a clean face is presented to the plate. Start the wipe from the far side and draw towards the near side. The plate is turned so that the work is carried out in all directions.

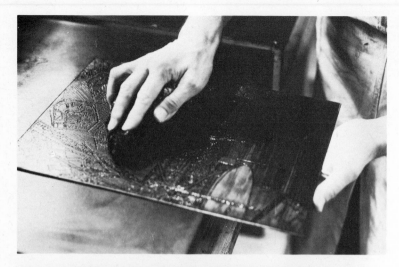

(b) Wiping the plate with a muslin pad heavily impregnated with ink. The underside of the plate is held by the hand

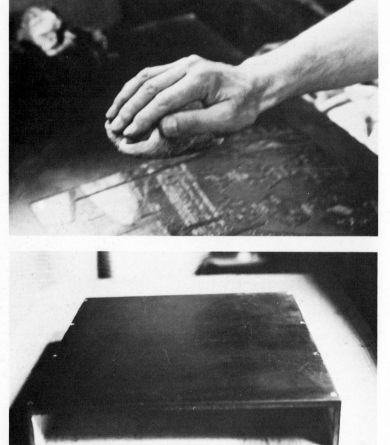

(c) The second pad. Note the manner of holding

Jigger. This one was home-made out of plywood (ply 5)

Second pad

Move the plate to the jigger, a hollow wooden box open at both ends, standing 10 cm (4 in.) from the table, next to the hot plate. Use a second pad with less pressure and in a circular movement. The lighter the wipe, the more ink removed from the surface and the less from the lines. The pad can be warmed on the hot plate to aid the removal of ink.

Third pad

A third pad is used in a fast and light polishing motion, removing most of the ink from the unbitten surfaces. Do not attempt to remove all the ink; a thin film should remain consistently over the plate with no streaks or spots.

Hand wipe

Transfer the plate back to the hot plate, and by keeping it in motion, do not allow the ink to overheat and bubble. Rub a little ink on to the fleshy part of the palm and, with wide sweeping and relaxed movements, brush the plate with the hand. If the hand jumps or squeaks there is too much pressure. The hotter the plate the more tone and less contrast will be left on the plate, the colder, the less tone and more contrast.

To remove as much surface tone as possible the hand can be very lightly dusted with whiting, which is continually renewed as the hand wipe progresses. Take care not to allow any surplus whiting into the lines as it will prevent them from printing.

Different tones are produced by varying the speed and pressure of a wipe. Different effects can be produced by printing after the rag wipe, producing a somewhat hazy tone compared to the print taken after the hand wipe, which can vary depending on the amount of surface tone left on the plate.

The hand wipe
(a) The hand with ink rubbed into the fleshy parts of the palm

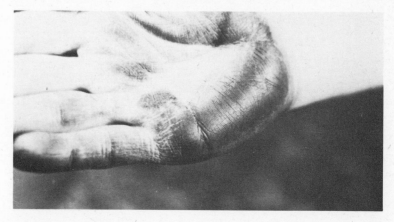

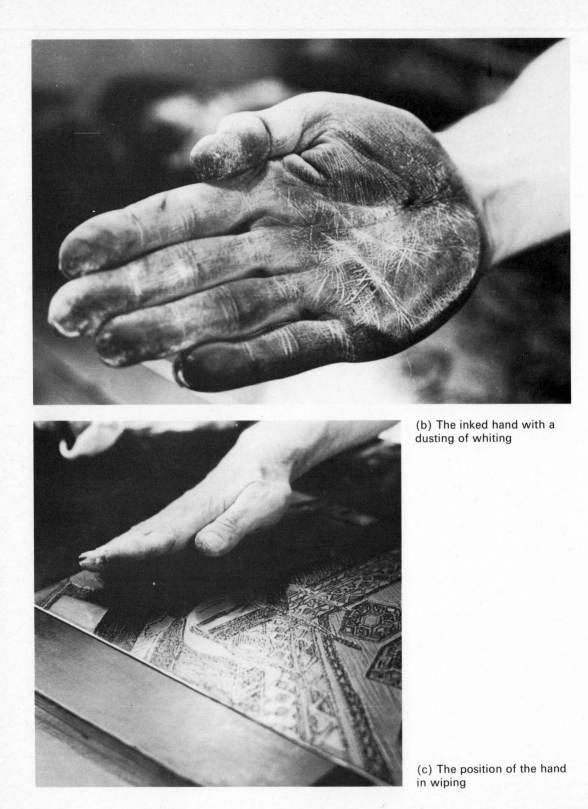

(b) The inked hand with a dusting of whiting

(c) The position of the hand in wiping

(d) Wiping the edges clean with a rag wrapped around a finger

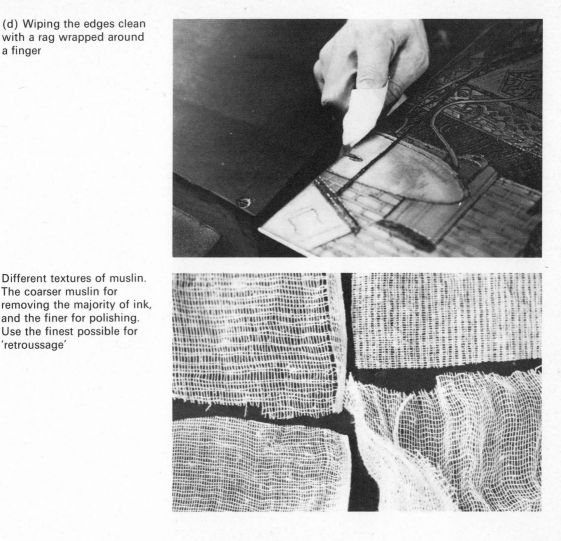

Different textures of muslin. The coarser muslin for removing the majority of ink, and the finer for polishing. Use the finest possible for 'retroussage'

Retroussage

Retroussage is a process which is used to enrich the print by drawing ink from the depths of the bitten lines up to their edges. Roll a piece of soft, close-textured muslin into a sausage and holding the roll by one end drag it very gently across the plate in all directions.

Before printing wipe the bevelled edges of the plate with a clean rag. As some ink will inevitably have found its way on to the back of the plate, a piece of tissue paper on the bed of the press beneath the plate will prevent the ink from being transferred to the bed, blankets or paper. The tissue paper should be changed as each print is taken.

Handling of Paper with Cardboard Fingers

Because the hands are inky, always handle the paper with artificial fingers, small rectangular pieces of cardboard bent so as to spring open when not in use. With these fingers lift the top sheet of paper from the stack and, laying it on a clean piece of glass, blot off the surface moisture. Turn, and blot the other side. The right side of the paper is that which, when held to the light, reveals the watermark the correct way round. With a soft brush, lightly brush up the nap or right side of the paper. Holding the paper by opposite corners with the card fingers, gradually lower it from one end on to the plate.

Fold down the blankets, pulling gently before they touch the paper to remove rucks and creases, and send through the press. Fold back the blankets and in a slow but single motion from one corner, lift the print with the card fingers.

Printing
(a) Blotting excess moisture from a sheet of paper taken from the stack, which lies beyond

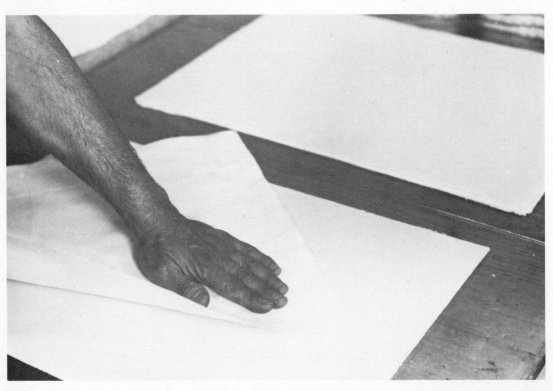

(b) Brushing the nap

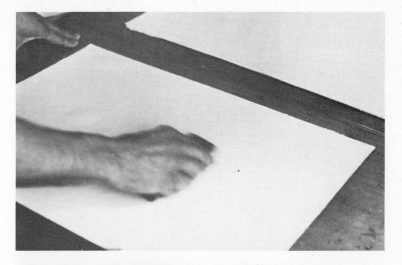

(c) The artificial fingers

(d) Laying the plate on to the bed of the press. Note the sheet of tissue paper which will help registration (positioning) and serve to keep the press clean

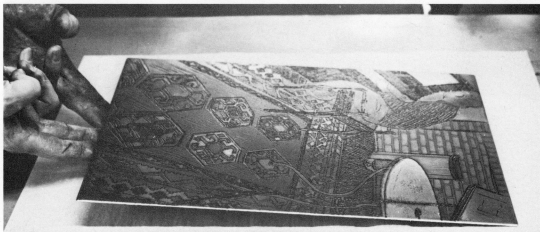

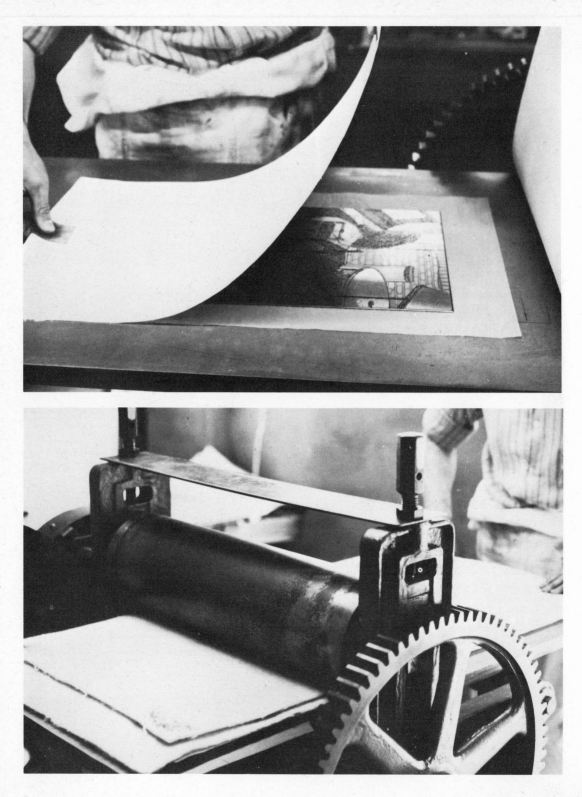

(e) Laying the paper on the inked plate. Note the artificial fingers
(f) Sending the plate covered by paper and blankets through the press
(g) Lifting the print from one corner in a steady movement with artificial fingers
(h) Covering the dry print with tissue paper

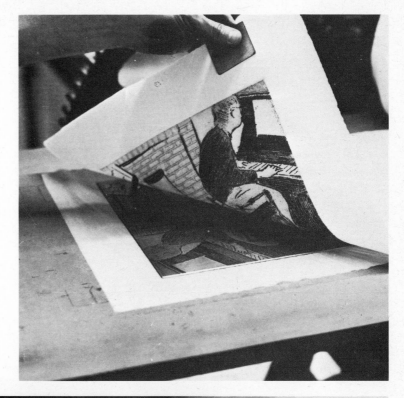

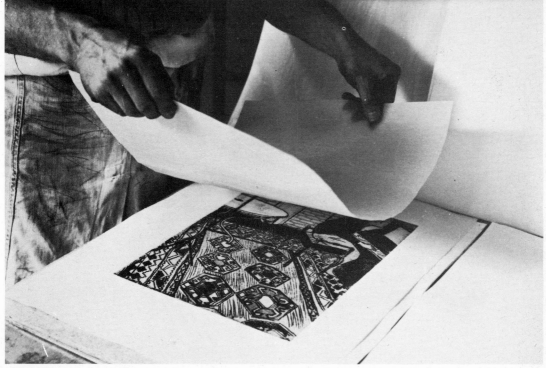

Printing Errors

If the print has a shiny surface, there is too much pressure on the press, but if the surface is shiny in only a few areas, the paper was not properly dampened. If the ink has spread out of the lines, there is either too much oil in the ink or too much pressure on the press. A double image is caused by either blankets that are wet and stiff or by uneven pressure on the screws. For lines that have printed improperly or not at all, compare the plate with the print; it is possible that the paper may have been too dry, but the cause will more often be the hurried lifting of a proof, a badly inked plate, ink that is too dry or even insufficient pressure. Ink will be absent on both print and plate if the inking was badly done, or will adhere firmly to the plate if the ink was too dry, and wet ink will be found still in the lines of the plate if pressure was insufficient. If a few lines are missing in an otherwise good print, the fault was probably in inking or because of dirt that lodged in the lines.

Drying and Stacking Prints

After lifting a print, lay it face up on a piece of blotting paper. After an hour or two the ink will be dry enough to stack prints on top of one another. Lay a piece of tissue over the print, then a piece of blotting paper, the next print, and so on. By this method there will be some offsetting of the ink on to the tissue, but to avoid this, leave the individual proofs for as long as 24 hours before stacking. Place the stack between 2 pieces of thick hardboard or chip board and leave under an evenly distributed weight, such as a sheet of plate glass, until the prints are dry, renewing the blotters and tissues every 12 hours. This will ensure that the prints dry flat and retain the plate marks. Any spare sheets of paper should be dried in the same manner before storing. The blotters can be dried for further use.

Cleaning and Storage

After printing, release the pressure from the screws, and remove all the blankets. If the *Swanskin* blankets are damp, they should be hung up to dry. If they are dirty or stiff with size, they should be washed by hand in warm water with a little soap, rinsed and dried. When they are dry, wrap them in paper and store with mothballs.

Clean the plate with paraffin or white spirit, dry with a clean rag and warm gently on the hot plate. If the plate is to be stored for any length of time, wipe it over with an oily rag. Lay the plate face down on tissue paper and wrap up well. Remember to clean the plate of oil with white spirit before reprinting.

The pieces of muslin should be scraped of ink, unfolded and hung up to dry. All surfaces and tools, plastic rollers, etc, should be thoroughly cleaned with paraffin or white spirit. Thorough cleaning after printing saves a lot of unnecessary time wasting before printing. Ink can be removed from the hands with *Swarfega*.

Cleaning and storing
(a) Wiping ink off the plate with white spirit after printing

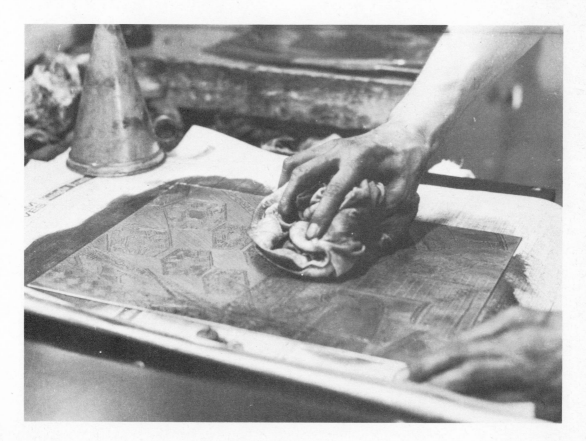

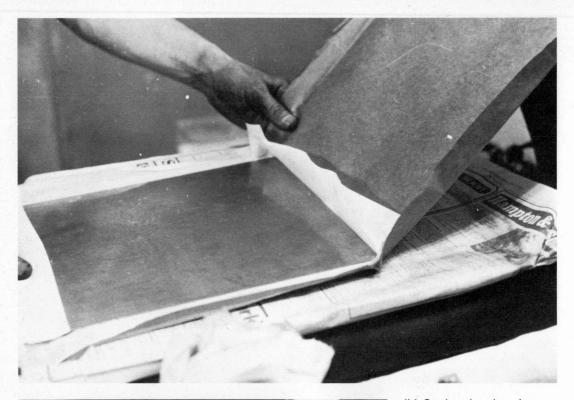

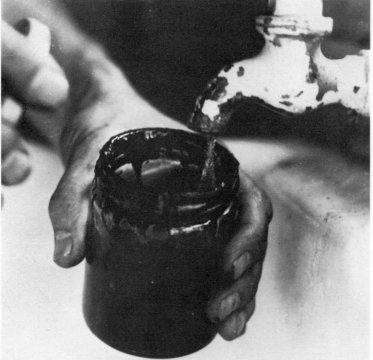

(b) Storing the plate. Lay the plate face down on tissue paper
(c) Unused ink is covered in water and kept in a jar

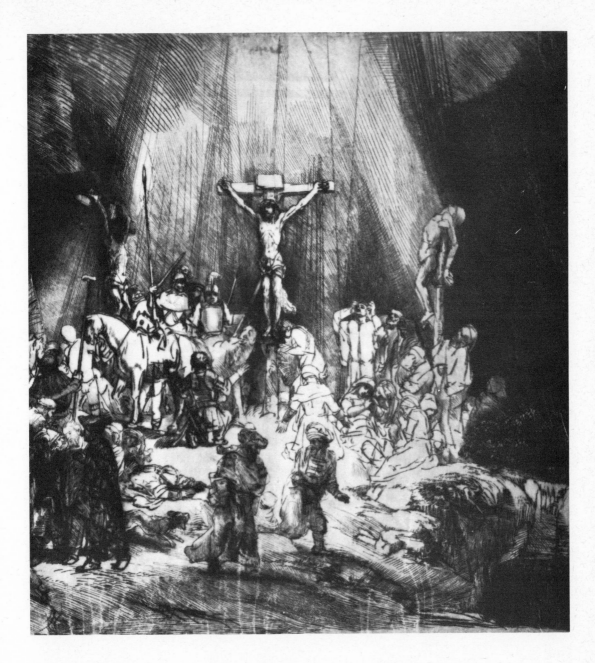

The Three Crosses by
Rembrandt. The British
Museum, London. Drypoint
and burin. Unquestionably
Rembrandt's finest
achievement in the medium.
He uses the needle with as
much effect as he does a
brush, and with the same
power of expression.
Preparatory studies for this
plate are unknown, which
suggests that he worked
directly on the plate. The
vigorous re-working of the
plate through its various
states included complete
changes in composition,
considerable re-drawing and
continual modification of
tone. Rembrandt also
experimented with the
printing of the 4 states,
producing 11 proofs on
different papers. A
comparison of these states is
staggering

Corrections
and alterations

An etched line can always be removed, and the etcher should never be afraid of making a mistake. Indeed, as the plate progresses, the design may be modified and certain areas will have to be removed. The burnisher and the scraper are the tools most useful in removing unwanted lines. But, because modification is an integral part of working in this medium, these tools are used in a positive manner. They lighten tones and alter the quality of a line as well as removing marks altogether.

Because ink is held in the plate by lines or roughened surfaces, a smooth area, though lower than the surface level of the plate, will not necessarily hold ink. It is on this principle that the use of the scraper and burnisher depend. They remove lines and tones by rendering the surface less retentive.

Materials for corrections and alterations: *Brasso*, oil rubber, snakestone, charcoal for oil and water, large piece of snakestone, scraper, scraper and burnisher combined, burnisher

Removing Scratches or Lightly Bitten Lines

Materials: scraper, burnisher, machine oil, snakestone, charcoal, pumice powder, *Brasso*, emery paper, round-headed hammer, blotting paper, calipers

The burnisher
Use the burnisher to force the sides of the line together, so that it will not hold ink. The tool is pushed back and forth across the line with the aid of a little machine oil. The direction of burnishing should be changed frequently until the line disappears.

Burnishing the plate with a little oil

60

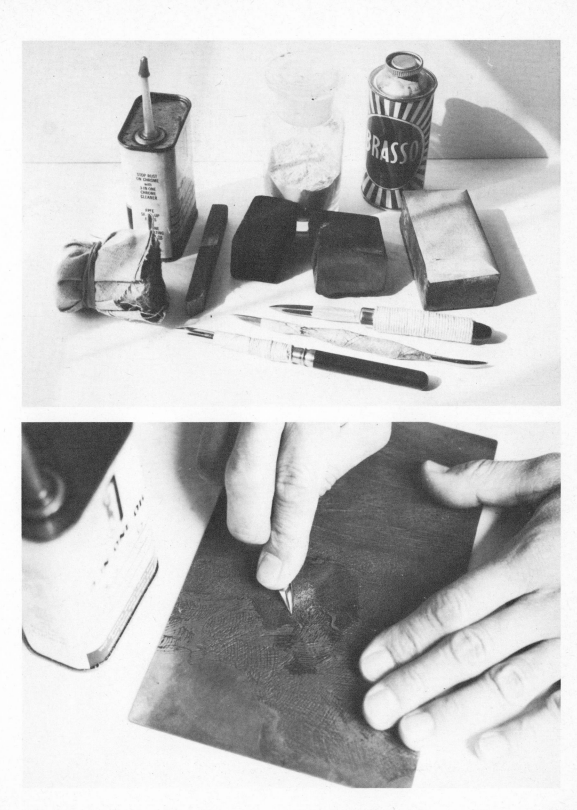

The scraper

The scraper removes deep lines, and the deeper the mark, the wider the area that should be scraped. Hold the scraper between the fingers and thumb, almost horizontal, and draw it across the line so that powdered metal is produced at each stroke. Change the direction of scraping until the mark has gone, and then remove the marks left by the scraper with the burnisher.

Large areas that have been overbitten by the acid are scraped away, and the marks left by the scraper removed with snakestone and water. Snakestone is a soft stone that is used like an india rubber to remove scratches and shallow lines. The marks of the snakestone are removed in turn by charcoal. The size of the piece of snakestone or charcoal will obviously depend upon the area to be worked. Both should be shaped like a wedge that is rounded and has no rough edges or any irregularity that might scratch the plate. Avoid sudden jerks, and push from the heel of the hand with a smooth planing motion. When using the snakestone, frequently dip it in water, otherwise it will polish and not cut. Use the charcoal in the same way to remove the marks left by the snakestone. Charcoal used with oil produces a finer cut than charcoal used with water, and can be used to

Scraping the plate, producing powdered metal at each stroke

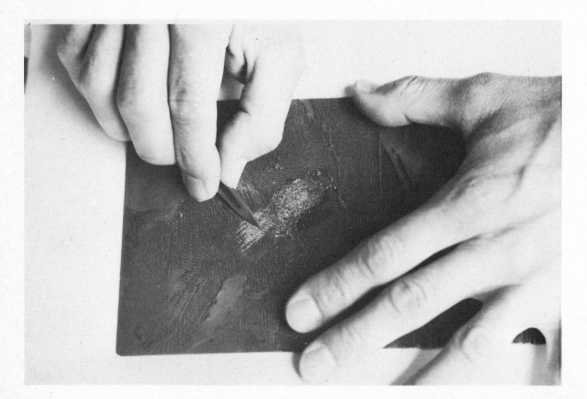

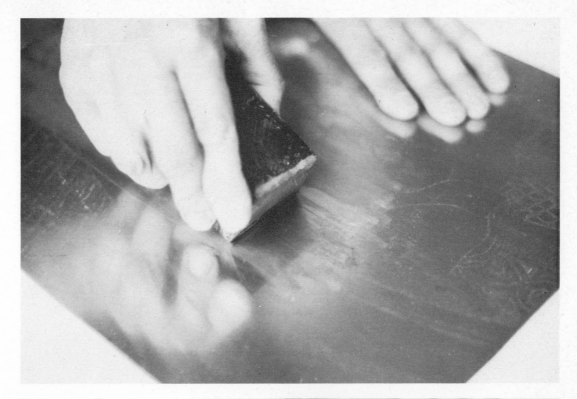

Snakestone with water

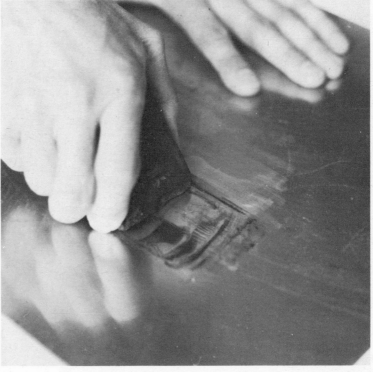

Charcoal with oil

remove any remaining marks. A very fine pumice powder rubbed on the plate with water and rag acts as an abrasive polish and can be used instead of *Brasso*.

Brasso, rubbed on with a rag, will give the final polish to the area. It will also remove tarnish, though if a bitten plate has been stored for a long period of time, small areas of tarnish can be effectively removed by a mixture of salt and acetic acid.

Repoussage

It is possible that a hollow which will collect ink has been ground out during these processes, and it will be necessary to press up the surface of the plate from the back. With a pair of calipers, mark the corresponding area on the back and laying the plate face down on a hard, even surface, gently tap the spot with a hammer. A special repoussage hammer can be obtained, though an ordinary round-headed hammer will do just as well. Remember, always pad the front of the plate and protect it from damage. When the plate is approximately level, equalize the surface with charcoal and oil. An alternative to this method is to stick pieces of blotting paper to the back of the plate and run it through the press.

If further work is necessary then a new ground should be laid.

Re-grounding a Plate

Materials: hard wax ground, dabber, roller, stop out varnish, hot plate, whiting, rags

Clean the plate as described above being sure to remove all the whiting from the bitten lines. Lay the new ground on as before, taking particular care to protect the edges of the lines. Before reimmersing the plate in the acid, check that the sides and back are varnished.

If lines that have already been bitten and proofed, that is, printed to see what they look like, need to be stronger then a ground is required to cover the unbitten surface so allowing the acid to attack the lines for a second time. Because of the difficulties in laying such a ground, it will be very thin and liable to scorch and to swamp fine lines. Care must be taken therefore not to warm the plate more than is sufficient to move the ground with a roller. Lay a ground on a plate of the same gauge and

adjacent to the working plate, and roll the ground lightly with a roller from one plate to the other.

To bite this ground use a very weak solution of nitric acid. The corners and junctions of the lines are bound to be rounded and the cross-hatching will probably lose much of its clarity.

This process should be avoided if at all possible, because the problems involved often give haphazard results.

Polishing the plate with *Brasso*

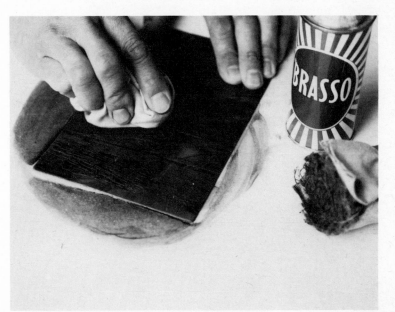

Filing the edges

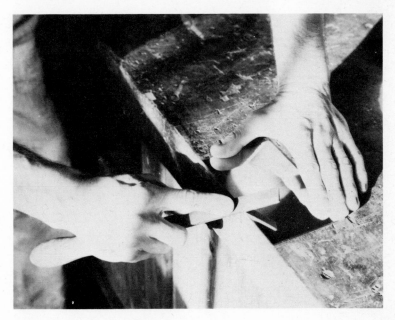

The Burin

Adding a line without re-grounding can be done with an engraving tool, the burin. The tool lends itself to etching because it does not displace but removes metal from the line. It is essential that the burin is in good condition and sharp so that it cuts and turns with perfect freedom (for sharpening, see Appendix). Lay the tool flat on the plate and pick it up, with the handle in the heel of the hand, between thumb and middle finger. The index finger rests on the plate as a guide while the other two fingers are tucked out of the way. Keeping the wrist and arm rigid, move the plate with the other hand against the point, so that a spiral of metal coils out of the line. The thickness of the line is determined by the weight of the hand on the burin, and by the shape of the shaft. A shaft with a square section will cut thicker than one with a lozenge section.

Woman with an Arrow by Rembrandt. The British Museum, London. First state on white paper. Rembrandt worked over an etched basis with drypoint and burin

The burin

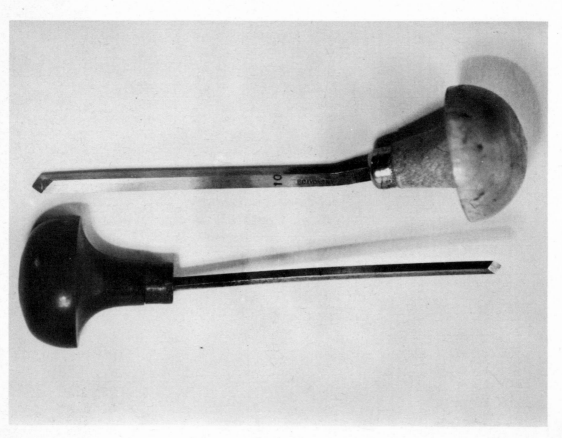

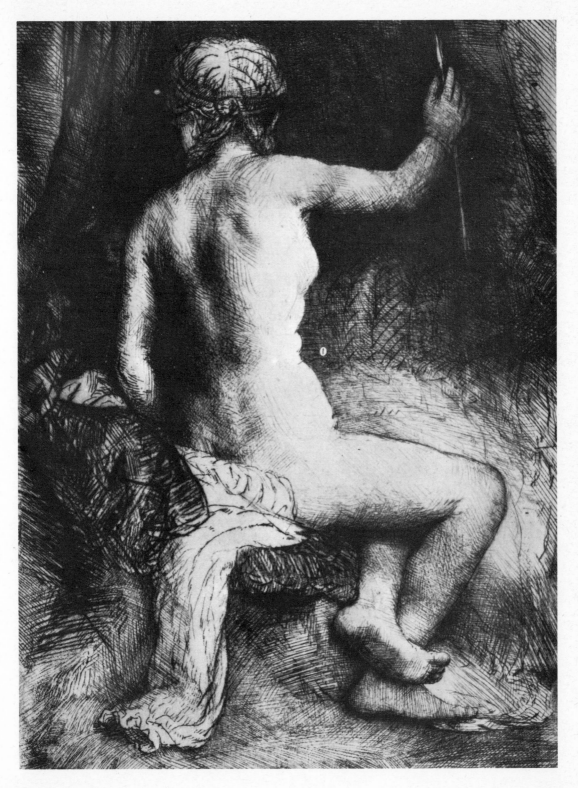

Drypoint and other processes

Materials: steel needles and diamond points, vaseline, printing ink, scraper, burnisher

Drypoint, as the name implies, does not involve the action of acid, and therefore no ground is necessary. It is the simplest and most direct manner of setting down a line on a metal plate that can be printed. The printing ink is held not in the groove but by a ridge of metal displaced from the line by the passage of the point. This ridge is called a burr and the strength of a printed line will depend upon the size of the burr. A line with a good burr will print with a distinctive velvety richness. Zinc is too soft a metal and not very suitable for drypoint because the burr is quickly worn down by the pressure exerted during printing.

Drypoint Needles

Hold the steel point like a pencil, remembering that it is not the amount of pressure that determines the quality of a line. Down to a certain angle, the less angle between the plate and tool, the greater the burr. When the tool is too acute, the burr will be completely cut out and print like a fine etched line. It follows that the more perpendicular the point, the less strength of line will be produced. The point must be kept sharp otherwise drawing will be hard work. There will be some resistance against the point when it draws across the grain of the metal. Consequently care should be taken when drawing a curve. Care should also be taken not to slip off the edges of a plate and break the diamond or blunt the steel.

Drypoint needles
1 and 2 Steel points, heavy and light. Note wrapping for improved grip, 3 Diamond point

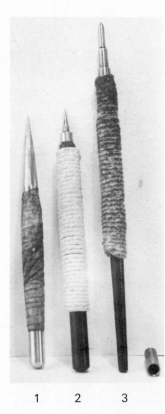

1 2 3

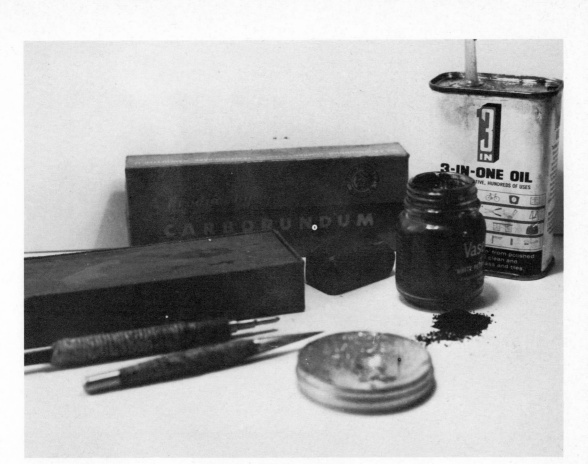

Materials for drypoint: oilstone, oil, vaseline, dry ink powder, drypoint needles

Diamond Point

A diamond point has the advantage of a very free movement. It yields a broader mark than the steel point at the same pressure. With the steel point there is a corresponding loss of mobility with an increase in pressure.

A scraper can be used to remove the burr from a line and modify the strength of a line. With the scraper almost horizontal to the plate an edge of it will cut the burr from a line. A burnisher can be used as an india rubber to modify the richness of the line or remove it altogether by pushing the burr back into it.

By rubbing a mixture of vaseline and ink into the lines, the marks can be seen in relation to each other as they are drawn.

Printing

The drypoint plate is inked and printed in the same way as an etching, but only 10 to 15 prints at the most will be identical. If a large edition is required, the plate should be steel faced. See Appendix.

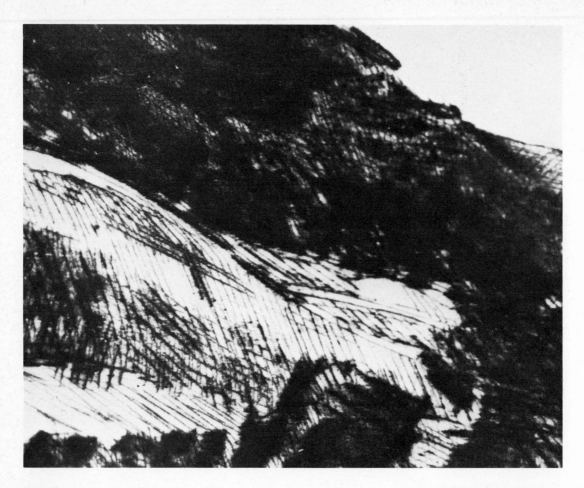

Soft Ground

A detail of drypoint line. The burr retains ink especially in areas of cross-hatching

Materials: soft ground, dabber, roller, hand rest

The principle of soft ground etching is that the ground adheres to anything that is brought into contact with it. The metal is laid open to the acid by the removal of the ground in this way.

Laying a soft ground
When the plate has been thoroughly cleaned with whiting and ammonia, the ground is laid as described in the chapter on hard ground. However, soft ground melts at a much lower temperature than hard, so after the initial heat to melt and spread the ground, rolling or dabbling should be completed away from the heat. A gentle heat after a ground has been laid will give an even distribution. It should not be as thickly laid as a hard ground, otherwise the results will be unpredictable. It is not necessary

to smoke a soft ground. It is important to keep dabbers and rollers used for hard ground labelled and separate from those for soft grounds. If a tool impregnated with one is used for the other, the ground will be ruined, and must be removed and relaid.

Caution: Do not touch the soft ground, as fingers will remove the ground and expose the plate to the acid.

Storage

A grounded plate can be stored or transported by laying it face down on a dampened tissue paper which is then stuck to the back with tape. Two such plates are kept face to face held together by elastic bands. The tissue paper will dry taut and protect the surfaces.

Drawing

It is possible to simulate in a print the appearance of a pencil drawing by drawing on to the ground through a sheet of paper. Do not use grease-proof paper or tissue as this does not stick to the ground. The thickness of the paper and of the point will determine the thickness of the line in the ground.

Biting

The plate is bitten in the usual way but the plate must be allowed to dry thoroughly before using stop out varnish.

Nitric acid will develop strong lines but will ignore half-tones. Dutch mordant will bite delicate shades of texture differences accurately. Naturally a combination of bites can be used to good effect.

The importance of this technique lies in the ground's sensitivity to any imprint. Though soft grounds can be purchased, a good ground can be made by heating 2 parts of hard ground with 1 part vaseline, axle grease or tallow. The amount of grease in the mixture will determine its sensitivity and prevent it from hardening. Textures such as cloth, gauzes and silks can be imprinted by pressing them into the ground.

When drawing on a large plate a hand rest is often an advantage. It is easily made from wood and is used as a bridge across the plate.

The bitten line in soft ground etching has a grained quality that is particularly compatible with aquatint.

Aquatint

Materials: resin, aquatint box, hand shaker, bunsen burner, stop out varnish, straw hat varnish, methylated spirit, wire baking tray

Aquatint is a process of biting tone, not line, with a ground that does not wholly protect the plate from acid. The effect is a granulated texture consisting of small dots that can be varied in density, according to the tone required. Small particles of resin are laid on the plate, and heated so that they adhere to it and act as an acid resist, allowing the acid to bite between them.

Laying an aquatint
Before laying an aquatint ground, the plate must be cleaned of all varnish and grounds. The resin may be applied with the aid of an 'Aquatint box' or by hand.

Aquatint box
An aquatint box is a box filled with resin particles. When the particles are disturbed they fill the available space and gradually settle, the heaviest and largest particles first. The plate is inserted so that particles drop on to its face. It follows that the longer a plate is left before insertion, the finer the particles that will settle on it.

As can be seen in the illustration, the box is quite simple, with a rectangular paddle that can be revolved by a handle to disturb the resin. A flap is let into one side to take the plate and tray. Aquatint boxes can be bought, but are easily made. The simplest model would be an old tea chest, filled with resin, shaken violently, and the plate inserted on a wire tray.

Crush lumps of resin and put a handful or two into the box. More resin will have to be added on subsequent occasions as the inside of the box becomes coated. Stir up the resin and wait a minute or two to allow irregular pieces to fall to the bottom. Open the box and insert the plate on a wire tray or wire baking rack. Leave for about 3 minutes and then withdraw the tray very carefully, taking care not to disturb the dust by jolting or draught. Gently heat the plate with a bunsen burner beneath until the patch of resin turns yellow, darkens and sticks to the plate. Overheating will completely melt the resin so that it runs together. Keep the flame in motion so that particles do not scorch.

As a general rule enough resin has settled when the plate

The aquatint box. The handle at the side rotates the paddle visible through the flap, which disturbs the resin. The plate is then inserted on the tray and the flap closed

The plate on the wire tray. The plate rests on a larger plate to prevent draughts disturbing the resin particles

becomes the colour of the resin. The plate can be returned to the box as many times as is necessary. A coarse texture will result by leaving the plate in the box for a short time, whilst a fine granulation will result from a longer time. However, eventually the particles will be so close together that they clot when heated, producing a coarse texture. It is possible to obtain a very fine grain by waiting for as long as 10 minutes before inserting the plate. Compared with shaking the resin on to the plate by hand, the aquatint box is more efficient in laying an even and fine ground. However, it is possible to achieve a great variety of effect by hand.

Application of resin by hand

For a coarse grain, put crushed resin into a stocking and shake out the fine particles. Transfer the remaining particles to a sieve and gently tap the side of it over the plate. For finer aquatints, shake the resin through bags of muslin. By varying the number and the fineness of the layers of material, the texture of the aquatint can be determined.

A hand shaker can be made by removing the bottom of a lidded tin with a can opener. Cover that end with layers of muslin and fasten on to the sides of the tin with tape. The tin can be filled with resin from the lid. Hold the tin over the plate and tap the sides. It is always advisable to place the plate on a wire frame when applying an aquatint to allow easy handling and a free passage for the bunsen burner.

When the plate has cooled, paint out those areas to remain light with stop out varnish. Straw hat varnish is good to use with aquatints because, like the resin itself, it is soluble in methylated spirit. When stopping out, beware of using too much pressure, otherwise the brush may lift the varnish rather than apply it. The barrier marked by the stop out varnish will, on account of the aquatint grain, not be a straight even line. If a perfectly clean line is required, the stopping out should be done before the aquatint is laid. There is the possibility, though, that the varnish will burn when the resin is heated, but this can be patched up accordingly before biting.

Biting aquatints

Weaker acids are required for biting aquatints. For zinc, nitric acid should be used in a solution of no greater strength than 1 part acid to 15 parts water. For copper, the weaker Dutch mordant should be used. In the early stages of biting, the plate will show more contrast in tone than it will actually print, while in later stages the reverse is the case.

74

Applying aquatint by hand.
Using an old cocoa tin
covered with layers of
stocking, and knocking it
with the handle of a palette
knife

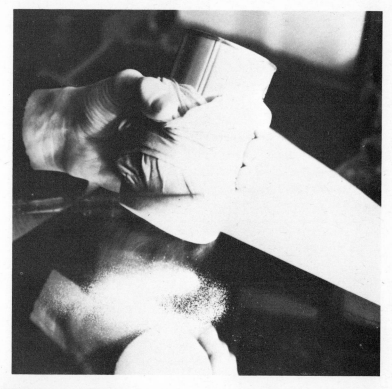

Heating the resin on a wire
tray with a bunsen burner

A fresh solution should be made for each bite. Remembering the factors involved such as the temperature of the acid, the timings for aquatint bites are approximately as follows: a medium grain aquatint on copper in a weak Dutch mordant will take about 2 minutes for a pale grey, 4 minutes for a darker grey and so on, until 90 minutes for black. For a fine grain, 1 minute for a pale grey, 2 minutes for a darker tone, and so on to black in 30 minutes. Experienced etchers know when the aquatint has been bitten sufficiently by closely watching the plate. At the point when the copper ceases to sparkle and the surface becomes an even tone, the plate is removed. If the plate is left after this point has been reached, all the resin will be bitten off and the tone will be lighter, not darker.

A coarse grain aquatint needs longer in the acid to print dark than a fine one. In general, a fine aquatint should be bitten half as long as a medium, which in turn should be bitten half as long as a coarse aquatint grain.

Aquatint resin is removed with methylated spirit. If the aquatint is too dark it can be lightened with a scraper and burnisher. If it is too light, lay another aquatint and re-bite. It is important that this second aquatint should be finer than the first, because a coarser grain would allow the acid to bite out the first aquatint, resulting in a grey probably lighter in tone.

Open Bite

If large areas of the plate are exposed to the acid without any acid resist whatsoever, different levels in the surface can be produced. These levels will print shades of grey and the line marking a difference in level will print like a contour. Grounds and aquatints can be laid on these levels giving a variety of effect that will differ from that achieved on the original surface. The main difference is that all work will appear embossed on the print; the deeper the surface of the plate, the more embossed it will appear. Depths of bite can be controlled by removing the plate and painting on stop out varnish before returning it to the acid. The bite can be continued if necessary until a hole is bitten right through the plate. Incidentally, this is a good method for biting out previous work. The work can be bitten to a faint impression or removed altogether.

Dutch mordant is a good acid to use for open bite as it leaves the edges of the ground intact, and a true line will be left, not an indented line as would be left by the bubbles of nitric acid.

Aquatint tones. A fine aquatint was laid on a copper plate and bitten in Dutch mordant, a solution of 3% potassium chlorate, 20% hydrochloric and 77% water. Band A was stopped out after 3 minutes, band B after a further 6 minutes (a total of 9 minutes) and band C after a further 12 minutes (a total of 21 minutes) and band D after a further 24 minutes, bringing the total time required for this black to 45 minutes

Seascale
(a) Detail showing first biting of lines drawn into soft ground. Note foul biting in sky. This was removed by snakestone and charcoal. Finally the areas were burnished and polished with *Brasso*

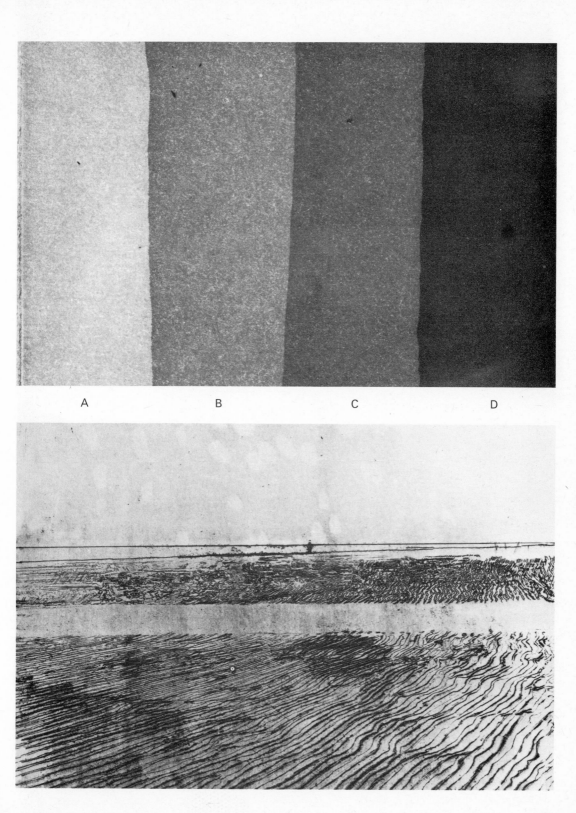

A B C D

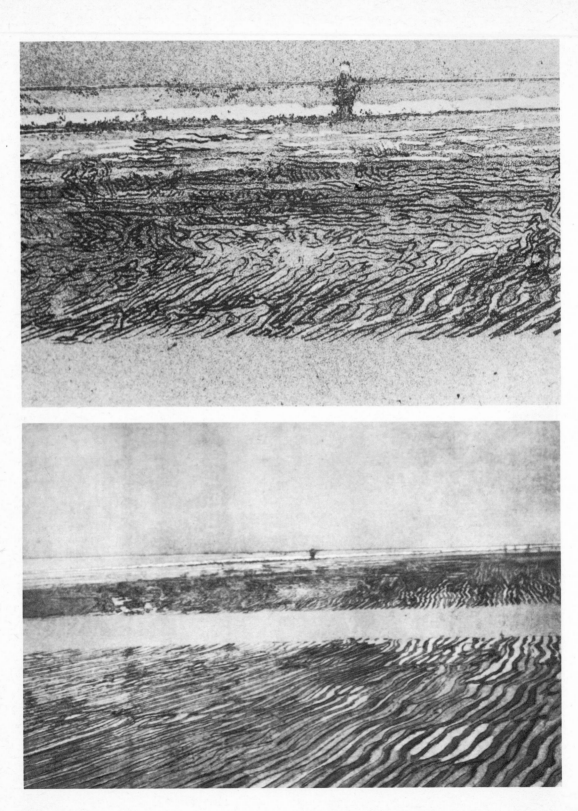

Sugar Solution

Whereas printing on the plate usually represents a negative process, in that the applications protect the plate and print light, a sugar solution will indirectly enable those areas to print dark. The solution is painted on and allowed to dry. A varnish is then lightly painted over the whole plate and allowed to dry. When the plate is submerged in water the varnish covering the sugar deposit breaks up, exposing that area to the acid.

If these areas are bitten without an aquatint they will print a light grey with a black perimeter. An aquatint will give the area a uniform tone.

Recipe

The sugar solution is made from 2 parts gum arabic, 2 parts liquid soap, 2 parts dissolved sugar and 1 part Indian ink. It should be warmed and thoroughly mixed and used as it cools, becoming tacky between the fingers.

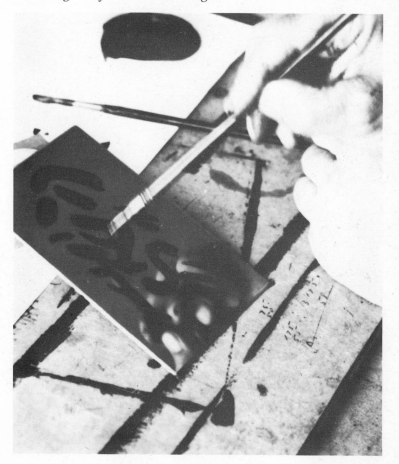

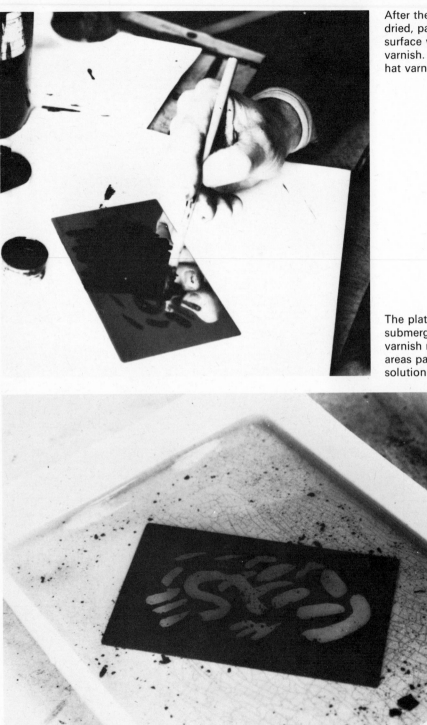

After the sugar solution has dried, paint the whole surface with stop-out varnish. In this case straw hat varnish was used

The plate is then submerged in water and the varnish rubbed off over those areas painted with the sugar solution

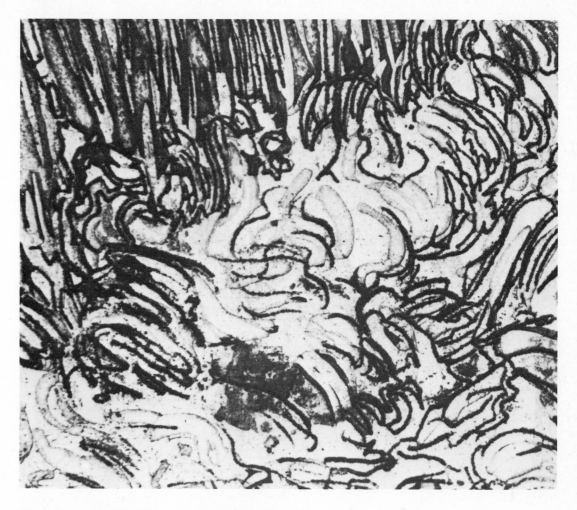

Detail showing original line drawing on soft ground, and half tones created by brushing on a sugar lift solution and aquatinting

Sandgrain

An alternative method of producing variation in tone, is to run sandpaper, face down on a hard grounded plate through the press. The sandpaper should be carefully lifted and sent through a second time in a different position. Stop out varnish can then be used before biting to protect those areas in which the grain is not required.

Saltgrain

If a press and resin are not to hand, then lay a hard ground and while it is still on the hot plate, sprinkle salt on it in the required density. Remove the plate from the heat and bite. The acid will dissolve the salt and penetrate the ground. The problem with sandgrain and with this method is that it is very difficult to estimate values of tone in the bath.

Epping Forest
(a) Original pencil drawing traced on to tracing paper

(b) Reversed tracing was laid on to the ground, the lines opened with an etching needle and bitten. (A small edition of 5 was taken at this stage.) After lines had been bitten, an aquatint was laid by hand, stopped out and bitten for various tones

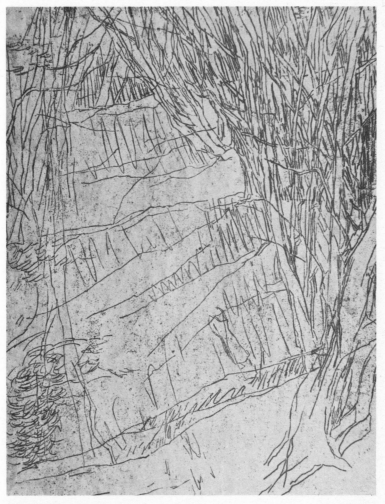

(c) Detail showing the variety of an aquatint applied by hand. A cocoa tin was used covered with layers of nylon stocking

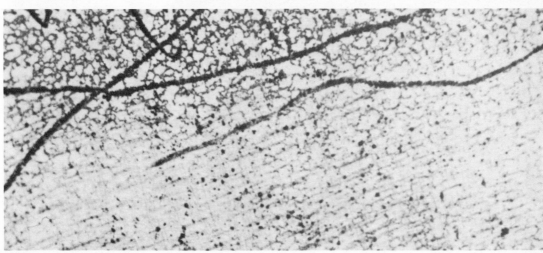

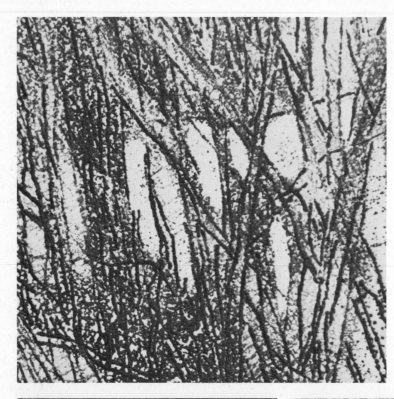

left
(d) Detail showing some areas originally aquatinted, now scraped to lighten the tone

bottom left
(e) Proof taken, showing badly bitten aquatint. Note the uneven effect of irregular grain caused by overheating the resin

bottom right
(f) Identical proof to (e) but in order to clarify and discover the design, the contrasts were heightened by drawing on the proof with white chalk and black crayon. Correction was then made to the plate with charcoal, scraping and burnishing, and final polishing with pumice powder and *Brasso*. A fresh aquatint was laid and bitten in various tones, by stopping out

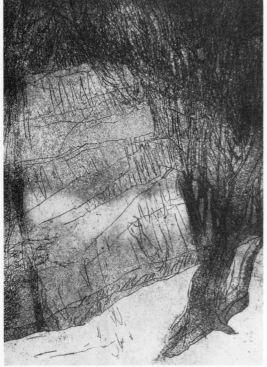

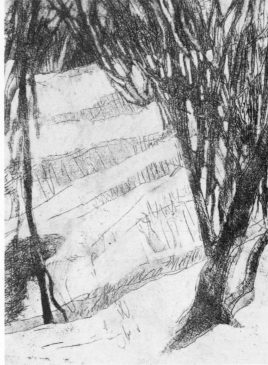

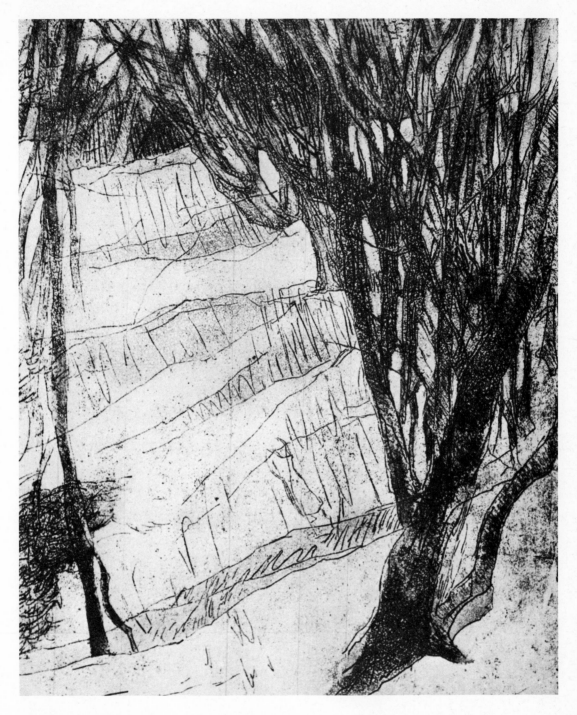

(g) Final print. Printed with equal parts of Frankfurt and Heavy French Black with a small amount of burnt sienna to produce a warm and dense black ink. The paper used was Barcham Green, Crisbrook hand-made, 140 lb, imp, soft sized. An edition of 10 prints was taken

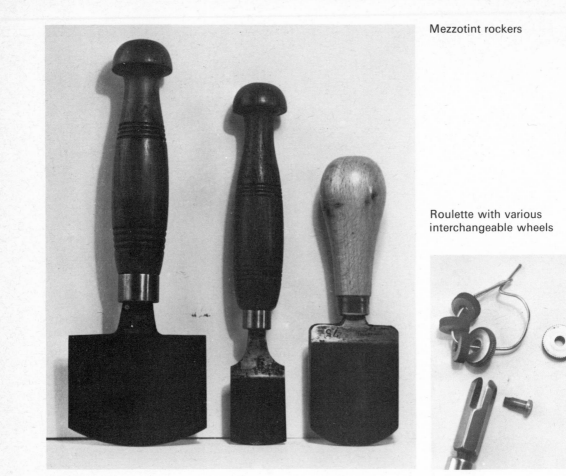

Mezzotint rockers

Roulette with various interchangeable wheels

Mezzotint

Materials: mezzotint rockers, roulette wheels, scraper, oil, ruler, chalk

Mezzotint is a process similar to drypoint. It does not involve the use of a ground or acid and prints from a raised burr. The plate is first prepared by raising a consistent burr on the surface to print a uniform black. The burr is then scraped and burnished where light tones or whites are required. It is a method of working from black to white.

Preparing the Plate

A mezzotint rocker is the tool that raises the burr; it is a steel chisel with a curved, serrated edge. Rule the plate into parallel lines with chalk, not more than a third the width of the rocker

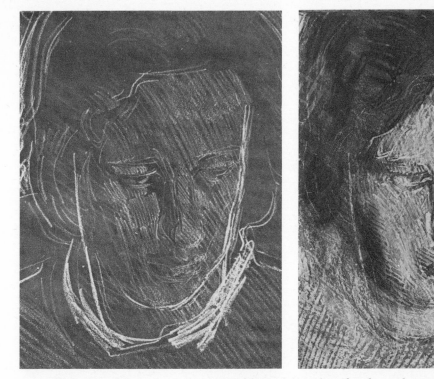

Assimilated mezzotint:
(a) The plate was originally laid with aquatint, drawn on with a wax crayon and bitten
(b) The plate was then scraped. The scraper was used in the manner of a pencil on the bitten aquatint to develop the drawing

apart. Holding the rocker firmly and starting from the far side of the plate, rock the tool from side to side moving very slowly down the lines. When this has been done, rule another set of lines at right angles to the first and repeat the process in that direction. The plate should be covered with very small dots that print black. If it does not print black, then rule up the plate in different directions and rock.

The scraper is then used to yield greys and whites. It will give a clear and harsh effect while the burnisher softens and lightens in a gentler fashion.

If a burr is to be raised in a small area a roulette wheel can be used. It is a small spiky wheel that turns on the end of a handle.

An alternative method of raising the original burr is to lay a coarse aquatint and bite it long enough to print black. See illustration of assimilated mezzotint above.

Printing

When printing mezzotint plates, the rag wipe is not used at all, but repeated hand wiping cleans the plate of ink. The ink should be slightly stiffer than that used for etchings; ink mixed with only heavy copperplate oil is suitable and will not streak. Apart from this, the manner of printing is the same as for drypoint.

The print

Editions

The number of prints in an edition will depend on personal choice. However, it will always be limited by the number of near identical prints that can be printed. A drypoint will print between 8 and 15 prints, while an etching will print anything up to 75 or 100. Editions usually number between 10 and 75.

After printing, select the number of prints for the edition, making sure that they are almost identical and do not vary in tone or density. They should be individually numbered as a fraction of the whole edition. Thus if the edition is 50, the tenth print will be numbered 10/50. The numbering is often done at the bottom left hand corner, the title in the centre, and the signature at the bottom right hand corner.

Mounting

Materials: white card, steel rule, sharp knife.

Take a piece of white card at least 3 mm ($\frac{1}{8}$ in.) thick and large enough to give a good border from 10 cm to 15 cm (4 in. to 6 in.) all round the print. Mark out the size of the print with an extra 1·3 cm ($\frac{1}{2}$ in.) at the top and sides, and 1·6 cm ($\frac{5}{8}$ in.) at the bottom, in the centre of the card. Using a steel rule, cut each line with a sharp knife, being sure not to over-cut at the corners.

Stick the print to the back of the mount with tape at each corner. A margin of paper should be left between the image and the mount to show the plate marks; 1·3 cm ($\frac{1}{2}$ in.) at either side

and at the top 1·6 ($\frac{5}{8}$ in.) at the bottom. Similarly the print looks balanced when the width of the mount is equal at the top and sides and wider at the bottom. If the mount is of equal width all round, the print looks top heavy.

The mounted print can either be framed, or set between a piece of glass and a piece of wood or hardboard the same size, held together by mirror clips.

The presentation of a print is important in that bad mounting often makes the print look worse than it is. On the other hand, good mounting may considerably improve a print.

Appendix

'It is good to know how one's materials are made, and to be able to make them (at a pinch); but it is only a waste of time for the student living within reach of a dealer to make up his own grounds, varnishes etc.'

The Art of Etching, E. S. Lumsden, Dover

Dabber
Cut a disc of thick card about 7·5 cm (3 in.) in diameter. Put a handful of furniture stuffing or horsehair on one side of the card and cover with a layer of cotton wool large enough to cover the edges of the card. Holding the stuffing in by gripping the cotton wool and the card, turn it on to a piece of soft kid or chamois leather. Fold the edges of the leather on to the back of the card and tightly bind them together with string so that the face is smooth with no wrinkles. The dabber should look like a mushroom.

Tampon
Tightly roll up a strip of finest felt about 10 cm or 12·5 cm (4 in. or 5 in.) wide, to a diameter of about 5 cm (2 in.). Bind the roll round with twine or string as tight as possible to about 7 mm ($\frac{1}{4}$ in.) from one end. Trim the end with scissors, and before using always check it for grit that might scratch a plate.

Muller and grinding slab
An old lithographic stone is excellent as a grinding slab. Alternatively a thick piece of ground glass will serve. A muller can be bought or made by a local stone mason.

90

Hot plates

Hot plates can easily be made by welding legs about 10 cm (4 in.) high on to a mild steel plate at least 7 mm ($\frac{1}{4}$ in.) thick. It is heated by a circular gas ring with a calor gas cylinder.

Stove tops can be used. Cover all the rings with a single sheet of mild steel not less than 7 mm ($\frac{1}{4}$ in.) thick. Heat the plate with the rings at their lowest heat as evenly as possible. When the plate is hot enough turn off the heat.

Hot plates can be purchased from suppliers but are expensive and it may be easier to find a local welder to make one.

Presses

The cheapest press is a conversion from an old metal framed mangle, but it has the disadvantage of not being able to sustain a great pressure. Similarly small table presses are comparatively cheap but have the same disadvantage. Both types are quite suitable for taking proofs to see how the plate is progressing. There is considerable competition for second hand presses which are occasionally available and which are often very good value.

Etching needles

Heat one end of an unbending steel needle red hot and jam it into a wooden holder, the wooden handle of a paint brush for example. The joint can be covered with sealing wax leaving 7 mm ($\frac{1}{4}$ in.) of needle free. Old gramophone needles serve the purpose very well.

Sharpening

Needles For thick conical shafts or drypoint needles, lay the shaft flat on the grindstone and grind evenly all round. Complete the sharpening on an oilstone until the end is sharp. An oilstone is a whetstone used with a little oil to sharpen cutting tools. A thin shafted needle will only require sharpening at the end on an oilstone. For etching needles, a smooth rounded point is required. Do this by describing ever-decreasing circles on the oilstone by gradually raising the hand.

The scraper Each of its three surfaces should be ground flat on the oilstone with a little oil. The edges between the surfaces should be perfectly sharp.

The burin Grind each of the faces of the shaft flat, applying the downward pressure with one hand while driving with the other. When the tool is properly ground no light or reflection should be possible between the edges. To grind the end face, hold the

shaft as near to the point as possible and grind it in a circular motion. The wrist and elbow should be rigid, and all the movement should come from the body.

Rust All steel tools can be cleaned of rust or dirt with 0000 emery cloth.

Grounds

Hard ground As found in *Etching, Engraving and Intaglio Printing* by Anthony Gross, OUP:

2 parts Gambia wax
2 parts Syrian bitumen
1 part rosin

Melt the rosin and stir in the other ingredients. Keep the mixture on a low heat for quarter of an hour to form a creamy paste. Throw the ground into warm water and knead it into convenient sized balls. As a general rule, rosin for stickiness, Syrian bitumen for brittleness, and wax for softness.

Liquid ground Heat the hard ground until it melts, take it from the heat and add turpentine. Allow to cool and cork in a bottle.

Soft ground Heat the hard ground for about 10 minutes, add the same quantity of grease – mechanic's axle grease is ideal. Mix well and pour in a steady stream into a piece of muslin submerged in water.

Stop out varnishes

1 part rosin
4 parts Syrian bitumen
Turpentine substitute

Melt the rosin and gradually mix in the Syrian bitumen. Cook for about quarter of an hour. Allow to cool and add a little turpentine substitute. Bottle and cork. It is best to leave the varnish 3 or 4 weeks before using. If the varnish is too brittle, add wax, but in the proportion of 1 part wax, 1 part rosin and 3 parts commercial bitumen. Soluble in turpentine substitute.

Straw hat varnish This is a good and cheap stop out varnish. It is especially good for use with aquatints because methylated spirit will remove the resin and the varnish simultaneously.

Solvents

Other bought stop out varnishes are not removed by methylated spirit but by turpentine substitute. All grounds are soluble in turpentine substitute. This is preferable to pure turpentine which leaves a sticky surface on the plate.

Wax
Gambia wax is the same thing as beeswax and should be purchased as such. Other commercial waxes are often based on petroleum. Syrian bitumen is harder than commercial bitumen, and should be used in grounds and varnishes. Commercial bitumen is good for softening stop out varnishes.

Liquid aquatint ground
A liquid aquatint is a solution of resin in alcohol and can be purchased in a bottle. Pour the solution over the plate, allowing the surplus to drain. The alcohol will evaporate leaving the resin stuck to the plate. Return the surplus solution to the bottle, being sure that impurities are not included with it.

The layout of an etching room
All the processes do not necessarily have to be carried out in the same room. But considerations of the needs of individual processes should be taken into account.

The acid room It should be well ventilated. The running water and sink should be as near to the acid bath as possible. Alternatively a second bath or plastic tray can be filled with water, though running water should be near at hand.

The printing room The hot plate and the jigger should be the same height and next to each other. The grinding slab should be as close as possible to them both. The press should be a few steps away and the paper stacks near at hand. The time taken in printing is cut down considerably if the materials are arranged conveniently together.

Aquatint If the aquatint box is in the same room as other etching materials, make sure that resin does not find its way on to them.

Suppliers

Equipment

L Cornelissen, 22 Great Queen Street, London WC2
Etching equipment and good dry colour stockists
Hunter-Penrose-Littlejohn Ltd, 7 Spa Road, London SE16
Very good all-round supplies, including etching baths and presses
C Roberson and Co Ltd, 77 Parkway, London NW1 799
Some etching materials, good diamond points

General materials

Ault and Wiborg Ltd, Stander Road, Smithfields, London SW18
Inks and Rollers
K A Engineering, 304 Cannon Hill Lane, Raynes Park, London
SW20
*Wax tapers, varnish, methylated spirit – and turpentine-based
hard, soft and transparent grounds*
Gilby and Sons Ltd, Reliance Works, Devonshire Road, Colliers
Wood, London SW19
Turpentine, rags, tinned inks
Griffin's Supplies for the Printing and Allied Trades, 20 Britton
Street, London EC1
Rollers, tools, acids, felt blankets
Usher and Walker Ltd, Chancery House, Chancery Lane, London
WC2
Inks and rollers

Papers

R K Burt and Co, 37 Union Street, London SE1 1SD
*Hand-made and mould-made papers and who also stock papers by
J Green, Saunders, Kent, and the French papers,*

Velin Cuve and Arches. Blotting, tissue and newsprint are also available
John Ford Ltd, Suite 500, Chesham House, 150 Regent Street, London W1
Double demy blotting paper and tissue paper
Green's Fine Papers Division, W and R Balston Ltd, Springfield Mill, Maidstone, Kent, ME14 2LE
Specialists in hand-made and Mould-made papers

Presses
Christopher Holladay, Modbury Engineering, Belsize Mews, 27 Belsize Lane, London NW3 5AT
Specialists in print-making machinery
Hunter-Penrose-Littlejohn Ltd, 7 Spa Road, London SE16
Harry F Rochat, Cotswold Lodge, Staplyton Road, Barnet, Herts
Also blankets

Blankets
Thomas Hardman and Son Ltd, Fernhill Mills, Bury, Lancs

Heating
Calor Gas (Distributing) Co Ltd, Calor Gas House, Key West, Slough, Bucks
Cylinders, gas rings, fittings etc

Steel facing of plates
Thomas Ross Ltd, 70 Hampstead Road, London NW1

Acids
Can be obtained from most local chemists